Say Cheese!

Say

Taking Great Photographs

Cheese!

of Your Children

Beth Galton
and Carol McD. Wallace

Photographs by Beth Galton

A Bulfinch Press Book
Little, Brown and Company
Boston Toronto London

Acknowledgments

The authors would like to thank the many people without whom this book could not have been written. In particular, we are grateful to Lisa Citron, Tony Jones, Patti Grimes, and Joe Luppino, for their expertise; to the photographers who generously supplied images; to the parents and children who posed so patiently; to Corlears School, for supplying so many photographic opportunities; and to Kodak, Fuji, and Ilford, for providing information and film.

We are also grateful to Lynn Seligman, for bringing us together; to Walter Klausson and Jim Hilboldt, for their legal expertise; to Deborah Jacobs, for meticulous copyediting; and to Lindley Boegehold, for her careful editing and enthusiastic support.

Text Copyright © 1993 by Beth Galton and Carol McD. Wallace

Photographs Copyright © 1993 by Beth Galton

First Edition

ISBN 0-8212-1935-9 (hardcover)
ISBN 0-8212-1949-9 (paperback)

Library of Congress Cataloging-in-Publication Data

Galton, Beth.
Say cheese! : taking great photographs of your children / Beth Galton and Carol McD. Wallace ; photographs by Beth Galton. — 1st U.S. ed.
 p. cm.
"A Bulfinch Press book."
ISBN 0-8212-1935-9 (hardcover)
ISBN 0-8212-1949-9 (paperback)
1. Photography of children.
I. Wallace, Carol. II. Title.
TR681.C5G35 1993
778.9'25—dc20 92-42402

Acknowledgments for photographs not by Beth Galton appear on page 150.

Bulfinch Press is an imprint and trademark of Little, Brown and Company (Inc.)

Published simultaneously in Canada by Little, Brown & Company (Canada) Limited

PRINTED IN SINGAPORE

For Edward and Maggie, who originally inspired my love of photographing children

For Ben and Tara, who have rekindled that love

And for Fred, who has provided unending support.

— B.G.

For Willy and Timo, my best subjects.

— C.McD.W.

Contents

viii Introduction

Chapter 1
2 The Camera
Lenses • The SLR • Compact Cameras • Other
Cameras • The Ideal Camera

Chapter 2
20 Film
The Choices in 35mm Film • Taking Good
Care of Your Film • Protecting Your Pictures

Chapter 3
30 Light
All Natural • Shooting with Flash

Chapter 9
100 On the Road
What to Take • What to Shoot • How to Shoot

Chapter 10
110 Action Photographs
The Best Vantage Point • Sharp Focus • Light
on the Subject

Chapter 11
116 Portraits
Getting Ready to Shoot • Equipment Check •
The Subject Is Children • Holiday Greetings

Chapter 12
128 Candids
Be Prepared • Your Point of View •
The Beauty of It

Chapter 13
140 Video Cameras
What's This Button For? • Ready, Roll 'Em •
The Tools of the Trade • Life As We Know It

146 Bibliography

147 Index

Chapter 4
44 The Subject
Dressed for the Occasion • In the
Background • Age-Appropriate • With a
Parent's Eye

Chapter 5
56 Composition
Getting Closer • Learning to Look •
Elements of Composition • Your Working
Method

Chapter 6
68 Baby Pictures
At the Hospital • Life with Baby • Older
Babies • Religious Ceremonies

Chapter 7
82 Party Shots
Simplify and Delegate • Scope It Out •
What to Look For • Stocking Up

Chapter 8
90 Milestones
Family Pictures • Holidays • Performances
and Transitions

Introduction

I never thought much about taking pictures of children until I had Ben. As a professional photographer, I specialize in shooting still lifes: food, fabrics, soft goods. This gives me the luxury of a lot of control; if the composition isn't right, I can move the carrots. If the lighting isn't right, I can take the time to adjust it without worrying that my subject is going to get bored and wriggle away.

Like every new parent, I was overwhelmed and exhausted after the arrival of my child, but as I started shooting pictures of Ben, I found to my surprise that I was using a lot of skills that I had acquired in my work. And as my enjoyment of taking pictures of him grew, I started photographing other kids as well. At first it was a challenge. You have to be flexible, because children won't always smile on command or they won't stay put or all they really want to do is grab for the camera.

Gradually, though, as I got used to taking pictures of children under lots of different circumstances, I was reawakened to things that I'd been taking for granted in my work. Simple, basic principles like looking at the picture you see through the viewfinder to see the *image,* not just the subject (it's easy to concentrate on the baby's smile, for instance, and not see the diaper pail in the background). Or always having a camera loaded with film in the same place, so if something wonderful is happening, you're ready to shoot. Or just being ready to get down on your hands and knees to find the best vantage point.

This book is basically about those principles, applied to taking pictures of kids. In the first five chapters I discuss the rudiments of photography. I'm not a technical photographer myself; it takes me a while to make sense of a fancy camera with millions of buttons on it. But while I realize that anyone, with any kind of camera, can take good photographs, I take an old-fashioned approach to photography. Though the recent trend in cameras has been to do more and more of the photographer's job, from focusing to winding the film, I believe it's important to understand the basics of how the image is getting onto your film. The system of setting shutter speed and aperture and focusing manually does mean that you (not a computer) control what you're going to see. It's not very complicated to learn, and I think it's worth it, so I run through those basics in the first part of the book. Still, lots of people (including me) will leave their camera on automatic or use a compact model. Even in these cases, certain variables will affect your pictures, like the kind of film you use, the lighting, the composition of your image. And there are special things to

think about when you're photographing kids, like the best way to make them comfortable at different ages. What works to warm up a three-year-old isn't going to succeed with a big girl of ten.

The second half of the book deals with specific occasions. I hope it will help take the mystique out of photographing them and allow you to make each situation work for you. Most parents take pictures of special events: a birthday party, a holiday, a visit with relatives, a vacation. These events all have their particular demands. For instance, vacations at the beach or in the snow present some tricky lighting situations. At a birthday party, things sometimes happen very quickly, and you need to be ready to capture the important moments without having the birthday candles relit three times. Halloween can be hard because children don't put on their costumes until it gets dark. And, since some of my best pictures of Ben were taken at the spur of the moment, I wanted to talk about recording those everyday scenes. They may be the ones we cherish most when our children are grown.

We'd all like to take the best possible pictures of our children, whether they're snapshots of the sandbox or the annual Christmas card. Without taking a lot of time or demanding a lot of expertise, this book, I hope, will help you do just that.

Say Cheese!

Chapter 1

The Camera

Mr. Potato Head posed for these shots in my studio one afternoon to demonstrate depth of field. Above, I shot at f/22. The Potato Head standing on the window ledge is perfectly sharp.

The shot to the near right was f/8, a medium aperture. The toy on the ledge has become fuzzy. The far right-hand shot was f/3.5, and the Potato Head on the right is now out of focus.

The first thing you should know about cameras is that you don't have to buy a new one to take better pictures of your children. There are extremely sophisticated cameras available today, and they can do amazing things. But chances are that by the time you become a parent, you already have a camera — or two. And you can take good pictures with them, even without such features as advanced microchip-driven sectional focusing capability.

If you are in the market for a new camera, the most important thing is to think about how you're going to use it. For instance, if you have older kids who are athletes, you may want to make sure you have a high maximum shutter speed and the option to use a telephoto lens. But if you'll be shooting mostly indoors, having a flash built into the camera might be a requirement for you. Do you want to be worry-free, to just point the camera and shoot? Or do you want to control the aperture and shutter speed, and focus manually? Talk to your friends, and try out their cameras if you can.

And no matter where you end up buying a camera, while you're shopping you should go to a good photo store and get a salesperson to show you various models. There's a lot of variety in the way they feel and the positions of the controls, so you should pick one that's comfortable for you. But the key point is to decide how technical you want to get. Be realistic. Are you honestly going to use a sophisticated single-lens reflex camera often enough to remember what all the controls are for? Or are you going to be frustrated by the lack of control with a simple compact? There are so many products on the market that you should be able to find one that exactly suits your needs.

Of course, shopping for (and using) a camera will be easier if you understand the basics of how it works — and not only because you'll be able to follow the salesperson's jargon. If you know how the camera functions, you can get the most out of each photographic situation.

To put it in the simplest terms, a camera is a box. Film runs through it. When light is let into the box through the lens, it creates an image on the film. The amount of light affects the way the image looks, and that amount is affected by the shutter speed and the lens opening, or aperture. The aperture controls how *much* light shines on the film, and the shutter speed controls how *long* it shines. That combination — aperture and shutter speed — makes up what's called the exposure. If too much light gets on the film, the picture will be too pale, or bleached out. Without enough light, the picture will be dark.

Let's go back to the **aperture,** because the concept can be a bit intimidating. If you look at the lens on a single-lens reflex camera (I'll be defining this kind of camera later in the chapter), you'll see little numbers on the barrel. They go from 1.4 (or sometimes 2.6 or 2.8) to 22, in a geometric progression. These are the f-stops. Inside every camera lens is a set of thin blades of metal. They overlap in a circular pattern, like the petals on a flower. The f-stop represents how far those blades will open when you take your picture; this opening is the aperture. The farther open the blades are, the more light is admitted. Now, what's confusing is that the higher the number, the smaller the opening. F/16 is therefore a small aperture, while f/2 is large; f/2 will let in a lot more light than f/16. (It might help to think of the f-stop numbers as fractions: $1/2$ is larger than $1/16$.) The other crucial point is that moving from one f-stop to the next, in either direction, will either double or halve the amount of light that enters the lens. In other words, f/5.6 admits half as much light as f/4 and twice as much as f/8.

Aperture also influences something besides the exposure: the depth of field, which is the zone in the picture that's in focus. Say your son is standing a few feet in front of a barn door. If you set your aperture to f/2 (nearly wide open) and focus on your son's face, the door behind him will be blurred. But if you shoot at f/16, you'll be able to see not only the details of his face but every splinter and nail on the barn door as well. A smaller aperture gives you greater depth of field.

You may never have noticed depth of field in photographs before, but it's a strong component of the way they look. For instance, sometimes it's helpful to be able to blur a background, either because it's unattractive or because you want to make your subject stand out more. This is a common technique in portrait photography. On the other hand, if

This is a shutter speed test, to show you what happens to moving subjects at successively slower speeds. From left to right: at 1/250, everything is in focus. At 1/60, the girl on the slide is blurred. At 1/15, she is even more blurred, although the girl waiting below is perfectly clear (she must have been standing very still).

you're photographing a group of children who are different distances from you, you'll need a lot of depth of field so that they'll all be in focus.

Of course, you also have to deal with **shutter speed.** The shutter may be either a set of parallel blades or a cloth curtain inside the camera. When you press the shutter release, the shutter pulls aside for a fraction of a second, letting light into the camera through the lens. As we've seen, the aperture controls how much light penetrates, while the shutter speed controls how long that light will shine on the film, in fractions of a second. If you look at the shutter speed dial on top of a camera, you'll see that it's marked in numbers from 2000 or 4000 down to 1, and then back up again (usually in a different color) to 2 or 4. These numbers represent either the fractions of a second — "1000" means 1/1000 of a second — or, usually shown in the contrasting color, the full seconds that the shutter stays open.

As you can see from the numbers on the shutter speed dial, each setting either halves or doubles the length of the exposure. Thus, each fraction of a second marked on the dial represents one "stop" of light, as they are also measured on the aperture dial. You can get the same exposure, the same amount of light on the film, by adjusting the aperture and shutter speed in opposite directions. For instance, if you set the shutter speed for 1/125 and the aperture at f/8, you'll get the same exposure as you would at 1/250 and f/5.6.

You won't, however, get exactly the same picture. By closing the aperture to f/8, you'll gain depth of field; the zone that's in focus will be greater. And shutter speed also affects the way pictures look. The slower the shutter speed, the more blurred the image will be. A fast shutter speed freezes action. If you are photographing a child sitting still, 1/60 is fine. Under that — at 1/30 or 1/15 — it's hard to

hold the camera still enough and hard for the subject not to move. The slower speeds are usually good for landscape or still lifes, but they require some kind of support, like a tripod. Photographing children generally entails using the faster shutter speeds. If you want to stop action on a speeding car or a racehorse, you'll need 1/500, but 1/125 and 1/250 will freeze the motion of a child running around the backyard. Don't assume that if your children are out on the lawn doing somersaults, you have to shoot them at 1/500. I find that some of my favorite photos of children show motion with a little blurring. And sometimes you need to make a compromise. Let's go back to an example I used before: say you're photographing a group of children at different distances from you. As I pointed out, you'll need a lot of depth of field to get them all in focus. So you'll have to stop down — that is, move to a smaller f-stop number — as far as you can without underexposing. To shoot at f/11 or f/16 and still get enough light, you may have to slow the shutter speed down and simply accept the blurring of some motion.

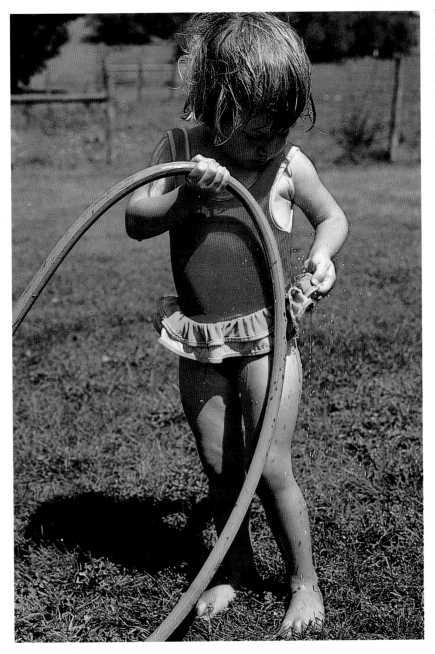

The luxury of shooting at midday is that there's so much light that you can use a very fast shutter speed and stop action. I shot this at 1/500, and the water droplets look almost solid. At a slower speed they would have been blurred.

One day there were three boys running around on our lawn, and when I grabbed my camera I forgot to check the shutter speed and ended up shooting at 1/60. To freeze action I should have set it at 1/250, but when I saw the contact sheet I liked the way Tim's feet were blurred. The shot captured his essence, which is perpetual motion. His body is in focus because it was moving slowly compared with his feet.

But how can you be sure you're making the right exposure? It's one thing to read about shooting at f/11 and 1/60, but how do you know you're really picking the right combination of shutter speed and f-stop? With most new cameras, you don't have to. In fact, with many new cameras you can't. The camera's microcomputer circuits will choose the exposure for you, based on information from the internal light meter. But in older models, and in cameras that let you override the computer and set the exposure manually, the display inside the viewfinder will indicate which aperture and shutter speed to select. You don't have to guess; the camera's meter determines this for you.

You could also use a technique called bracketing, which means shooting the same subject two or three times with slightly different combinations of f-stop and shutter speed. (This is really more productive when you're shooting slide film than negative film, which is formulated to compensate for exposure errors.) For instance, you may be shooting a group of kids on a swing set in mixed sun and clouds. You want to freeze the action, so you need to set the shutter at 1/250. Your camera's light meter indicates that you need an aperture of f/8. So you shoot at f/8, and also at f/5.6 and f/11, keeping the shutter speed constant. The shot with the smallest aperture might be a little underexposed, but it might be in better focus, since you'll have greater depth of field. It's worth shooting two extra frames and taking the chance that they'll produce a better shot.

Another factor affects the exposure, and that's **film speed,** also known as ISO. The speed of the film refers to how much light it takes to expose the film. If your ISO number is low, like 25 or 64, the film is slow. It needs a lot of light to make a correct exposure. A film with a high reading, like 1000 or 1600, needs less light; it's known as fast film. The various speeds and varieties of film have different characteristics; these are discussed in chapter 2, which examines film. What you need to know for now is that choosing the appropriate film speed can give you greater flexibility in shooting and increase your success rate. If there's not a lot of light you'll need a faster ISO, but if it's a bright day you can use a moderate to slow speed.

Choosing your film speed lays the foundation, and it's important to choose wisely, because whatever speed you select, you're stuck with it for the next twenty-four or thirty-six frames. And it will affect your other creative choices, i.e., aperture and shutter speed.

Lenses

I'm sure you've heard photo buffs talk about their lenses: 35mm with f/1.4 versus 50mm with f/2.8 — the numbers become overwhelming. And you see them walking around with their bulky camera bags and huge long lenses on their cameras. I used to think you had to have all that stuff to take good pictures. What I've found out through the years is that you don't need it unless you want it. It's true that more lenses give you more options, but I find it hard to use more than three lenses, let alone carry them!

I had a photography teacher in college who insisted that we use only our 50mm lenses for a few weeks. The 50mm is the lens that comes closest to normal vision. (The number on the lens, by the way, refers to the focal length, or the distance between the lens when it's focused on infinity and the film in the camera.) I became very comfortable with that lens and discovered just what it could do. I learned where to stand to get everything I wanted into the picture frame.

The photographs on these two pages represent a lens test, demonstrating three common focal-length lenses: 35mm, 50mm, and 105mm. Ben and I stayed in the same position for all three shots, and I kept the f-stop the same. You will notice that the 35mm (used in the shot to the left) is a moderately wide-angle lens that allows you to see most of the chair as well as the porch. Most of it is in focus, but the perspective is distorted — compare the size of Ben's knees with the size of his head.

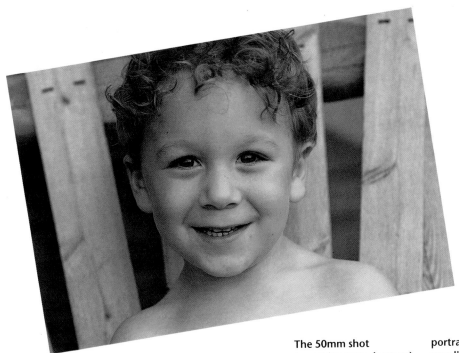

The 50mm shot (opposite page, bottom) is the one that's closest to normal vision. Above is the 105mm shot. The 105mm is considered a portrait lens; it gives you very little depth of field (notice that even the backs of Ben's ears are out of focus) and minimal distortion.

Then our teacher had us start using a 35mm lens. (Again, remember that this number has nothing to do with 35mm film, which most cameras use: it represents the focal length of the lens.) This lens is a moderate wide-angle, and it's found on a lot of compact cameras. Well, the whole world opened up. I got about a third more into the picture frame than I had been able to with the 50mm. I could worry less about focus, because a wider-angle lens has greater depth of field. Since the objects in the foreground were a little bigger than normal, and the ones in the background were a little smaller, perspective was a bit exaggerated.

Which was fine, except when I was taking pictures of people — their noses looked very big and their ears seemed miles back on their head. I went back to the 50mm for my portraits.

Next we worked with longer lenses, like a 105mm. I found I had very little depth of field, so I had to be very precise about focusing. But my portraits looked great. The lens compresses faces, making the distance between the tip of the nose and the back of the ears appear very short. The background was pretty fuzzy, too, because of the shallow depth of field, which longer lenses are known for.

To sum it up, the 50mm lens most closely approximates normal vision. The wider lenses, like 35mm and below, offer great depth of field and can capture big expanses. The longer lenses, which give you less depth of field, are excellent for capturing something far away and enlarging it in the picture frame. This can be terrific when you want to photograph kids from afar and not disturb their play.

There's one other variable to consider when you're thinking about lenses. When you read ads for lenses, they'll give a number after the focal-length number: 50/1.8, or 35/1.4, or 85/4. The second number refers to the lens's maximum aperture. Remember, the smaller the aperture number, the more light gets onto the film. This is important, especially with a longer lens. The larger-apertured lenses (sometimes they're also called faster or brighter) give you more flexibility when you're shooting. A lens from 85mm to 105mm is perfect for close-ups of people, but if its maximum aperture is f/5.6, you may need to use very fast film, a very slow shutter speed, or flash, especially indoors. Although a faster lens can be a lot more expensive, you should buy the fastest one you can afford if you're in the market for a new lens.

Another important option when you're looking at lenses is a zoom lens. These lenses combine various focal lengths, allowing the photographer to frame the subject exactly the way he or she wants to. They come in all kinds of combinations, but some of the most common are 35mm–70mm, 35mm–105mm, and 70mm–210mm. Recent improvements in lens optics have made some of these lenses almost as compact and light as a 50mm lens, and it may seem sensible to simply buy, for example, a 35mm–105mm and cover all your options. I'm probably old-fashioned, but I don't recommend this. For one thing, the maximum aperture on many of these zooms is pretty small; they just aren't built to open up to f/1.8

or f/2, like your basic 50mm lens. So you may be pushed into using flash a lot more often than you'd like. And I suspect that most people who jump into buying zoom lenses don't really need that much lens.

I shot most of this book using a 55mm lens. Although I have enjoyed using a zoom lens on someone else's camera (and when I'm frantically changing lenses I wish I had one), I still feel more comfortable with that one lens. I know how it will make my pictures look, and I understand its limitations. That 55mm lens is a familiar tool that contributes to the look of my photographs.

Another reason I prefer using one lens is that the choices a zoom lens makes available are too much, too distracting. You start to second-guess yourself — Should I close in? Shoot tighter? What would this look like with the lens extended? You have to pay a little more attention to the equipment, and you lose some of your concentration.

I'm not trying to talk anyone out of using a zoom. There are times when having that range can be very helpful, especially when you're shooting children who move around a lot. I just want to point out that a zoom lens isn't a necessity for taking great pictures of your children.

If you are in the market for new equipment, I suggest shooting with a 50mm for several months. As you take lots of photographs you'll get to know what kind of situations you encounter most often. Maybe you do need a zoom to catch children playing without your presence interrupting them. Or maybe you need a wide-angle because you travel a lot and want to shoot scenery. But there's no point in investing hundreds of dollars in lenses you don't really need.

If you're thinking of buying a zoom lens, you might want to borrow one from a friend, or rent one from a photo store for a week or so, and see if it suits your normal shooting patterns. You also have this option for unusual occasions: you might be fine with a 50mm most of the time, but you could rent a 35–105 for a vacation. Another word of caution: camera equipment doesn't have to be expensive to be functional, but lenses are not something you can cut corners on. It makes sense to buy lenses manufactured by the maker of your camera. The new autofocus cameras in particular are full of computer circuitry that communicates with circuitry in the lens itself. Even if a lens and camera made by different manufacturers are supposed to be compatible, buying different brands seems to me like asking for trouble.

The trend, as I've said, is to take the work out of the hands of the photographer, which means that many of the cameras on the market today have autofocus features. With older cameras and lenses, those tiny adjustments of the lens are up to you. Most single-lens reflex cameras have a viewing screen that makes it easier for you to focus sharply. Microprisms are common, and so are split-image finders. You turn the barrel of the lens to align the portions of your subject as seen through the split-image finder. When they're lined up, your shot is in focus.

Focusing is one of the biggest headaches when you're taking pictures of children, because they move so fast and so unpredictably. With most autofocus cameras you press the shutter button halfway down, and as long as you keep your finger on the button the camera will hold that focus. But the problem is that children move quickly from their original positions and the focus is constantly changing. Autofocus isn't always fast enough to respond, so it's sometimes clumsy when you're working with children. At least if you are using manual focus you can adjust it constantly. On the other hand, you *have* to adjust it constantly. To my mind the choice between manual focus and autofocus is a toss-up. Sometimes autofocus is a tremendous help, and sometimes it gets in your way. Whether your camera focuses automatically or manually, though, remember to reevaluate the focus constantly. And remember that one of the reasons for shooting a lot of film is to make sure you get some pictures in sharp focus even though your subject is moving.

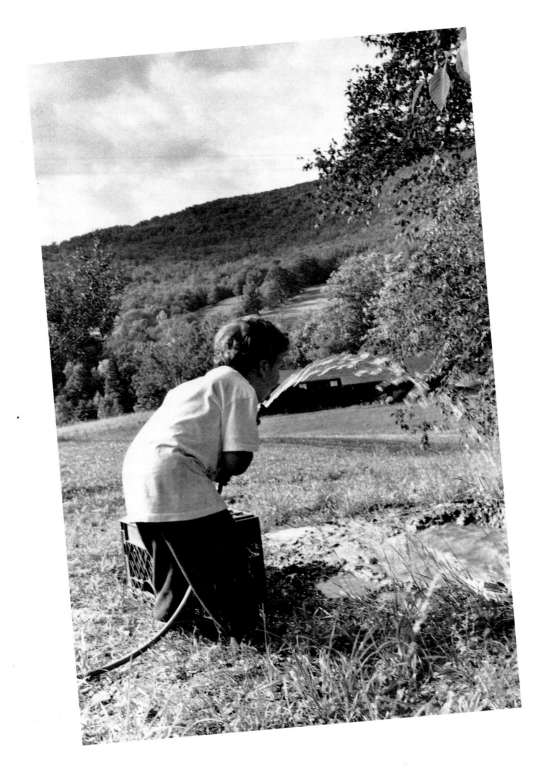

The SLR

The term single-lens reflex camera, or SLR, refers to the system that allows the photographer to look through the viewfinder and see the exact image that will be captured on film. With some kinds of cameras, like most compacts, the viewfinder is a hole in the camera that lets you see an approximation of what's going to appear on film. But the SLR permits you to see right through the lens. The way it accomplishes this is fairly complicated. The image enters through the lens, which turns it upside down and backward. Then, inside the camera, a mirror reflects the image onto the focusing screen and from there upward into the prism, a five-sided chunk of glass above the viewfinder. (The prism is the reason all SLRs have a pyramidal shape over the lens.) The mirror turns the image right side up, and the prism corrects it left to right. Without them, you would see a reversed, upside-down image through the viewfinder.

Because all SLRs use this mirror-and-prism device, they tend to be quite large and heavy. As a class of camera, they share other characteristics, too. Generally, professionals stick to SLRs not only because of the accuracy of the viewfinder, but also because they offer the greatest level of control over your pictures. With

some exceptions, they allow you to set your aperture and shutter speed manually or to attach a flash unit if you need it. You can also usually change the lenses on an SLR even if you're in the middle of shooting a roll of film.

But if you've looked at what's on the market today, you'll realize that advanced technology has significantly changed things. Although on some models the controls are still manual, automation is now the rule. The basic SLRs are now run by microchip computer circuitry. They have features like automatic film loading, automatic rewind, and automatic focus, which used to be found only on compact cameras. And in what the manufacturers call program mode, these cameras select the exposure for you, too. Some of them feature "manual overrides," which allow the photographer to make those choices. And the more advanced models have features like shutter speed priority (you set the shutter speed, it sets the aperture), aperture priority (you set the aperture, it sets the shutter speed), or special programs for portraits, still lifes, and high-speed photography. Some of the technology, especially when it comes to metering (measuring) light and focusing, is amazing. But I've seen cameras that have more controls than I could possibly manage. Many of them have LCD panels that pack a lot of information into a tiny space. You have to use them fairly often to remember what all those different numbers and initials and pictographs mean. I don't have anything against automatic cameras — many of them make it possible for even beginners to manage technically difficult photographic situations. It's also really helpful, when you're photographing children, not to have to worry about making the correct exposure. I'd simply caution against buying more camera than you need — or can remember how to use.

When you shoot outdoors in plenty of light, you can close down your aperture. I love the juxtaposition of Ben drinking from a hose with the panoramic background and the play of light on the hillside. That could only be captured with a small aperture: f/22, in this case.

Compact Cameras

I've spent a lot of time discussing SLRs, but there is another whole category of cameras that are hugely popular. These are the cameras known as point-and-shoot, or sometimes rangefinder or compact cameras. There are a few models that use 110mm cartridge film. They are very inexpensive, but you're not going to get great photographs with them. It makes more sense to use even the simplest 35mm compact. (I'm not talking here about the focal length of the lens; 35mm refers to the film size.) The larger the film, the better your picture will be. And 35mm film is no more expensive to buy or print than 110. What's more, there are more film options — faster or slower film, slides or negatives — if you can shoot 35mm.

Compact cameras function quite differently from SLRs. The camera is still a box with film running through it, and it does have a lens and shutter. But the most important difference to the photographer is the viewfinder. With the SLR, you're looking *through* the lens — you see what the camera sees, and that's going to be your picture. With a compact camera, you're looking through a window that's separate from the lens. What you see is not necessarily what you're going to get.

There are other differences, too. Even if your SLR is totally programmed and you can't change the aperture or shutter speed, it is variable; it can be altered for different conditions. This isn't true of a compact camera. The aperture is fixed, and so is the shutter speed on most cameras. (Some of the more elaborate models do have a few shutter speeds.) You also can't change the lens of a compact. Most of them come equipped with a standard, fairly wide-angle lens, like a 35mm. Some have two lenses or zoom lenses, options made possible as zooms have become lighter and more compact. But the maximum aperture of these lenses is usually pretty small, like f/4.5 at 35mm. They do have flash, and the more sophisticated models allow you to turn the flash off and offer a "fill-flash" option for what are known as backlight situations. (Your subject is backlit when the light comes from behind him, putting his face in shadow. Fill-flash is a low-powered burst of flash that removes shadows without overwhelming the natural light.) Many of them also now have some kind of red-eye-reduction mode, since that's a big complaint about these cameras. (This happens when the flash reflects off the subject's irises.) Finally, these cameras either have autofocus or fixed focus. Paying more for autofocus makes sense if you can afford it. Although the ones with fixed focus are supposed to work for distances from 4 feet to infinity, the focus isn't all that sharp.

I may have made compact cameras sound simplistic, but they aren't. I often use one myself because it's so easy to just grab and carry along. If you're juggling a stroller and a diaper bag and a couple of kids, that can make the difference between bringing the camera along or just leaving it behind. As I mentioned before, the autofocus that's a standard feature on these cameras can be a big help when you're

photographing kids. And these compact cameras also tend to be less expensive than SLRs.

But there are drawbacks. Everything in photography is a compromise of sorts, and with compacts, while you get a lot, you also give away a few important things. For instance, convenient as it is to have built-in flash, it goes off more than I would like. Although there are some times when you really need flash, I don't much like the results, which aren't very subtle. And because I don't have control over the f-stop and shutter speed, I can't change those settings to compensate for low light to get what might be a moody picture. Usually I end up just turning off the flash and using the camera outside.

The autofocus is great, but there are a couple of disadvantages to it. Sometimes it's not as sharp as it could be if I were focusing manually with an SLR. And another problem common to most autofocus systems is that they automatically focus on whatever is at the center of the frame. This is fine if you're shooting at some distance, or if you've got one person smack in the middle of the viewfinder. But say you've got two little girls having a tea party in front of a tree. You compose your shot so that the girls are at either side of the frame. Most autofocus systems would focus on the tree trunk rather than the girls, because they aren't in the middle. The resulting picture would have the bark on the tree in focus, while the girls would be blurred. There are ways to compensate,

though. The manuals for each camera differ, but usually you can focus on one girl by depressing the shutter button partway and then, with your finger still on the button, moving the camera so that the tree is again at the center of the frame. This is known as recomposing the shot. Most compacts and SLRs have this feature, which is called focus lock. It is actually very easy to use.

Another difficulty with compact cameras is the "parallax problem," which means that you don't always get what you see through the lens. With SLRs, as we've seen, because of the mirror-and-prism structure, your picture will be what you see through the viewfinder. But with a compact, you have to look for the faint lines in the viewfinder that indicate the boundaries of the picture for each lens. It's important to remember this, particularly at short distances. Sometimes I shoot very tight on a subject with a long lens and forget to look at the indicator lines for that lens. I end up chopping off part of the person's head! And for some people it's hard to visualize what the photograph will look like, just on the basis of these little gray lines. If you're considering buying a compact camera, make sure to check the viewfinder with this in mind. These markings are easier to see on some cameras than on others.

Finally, compact cameras and most new SLRs run on expensive lithium batteries, and you have to remember to turn the camera off if your model doesn't have an automatic shutoff. There's nothing worse than running to take a picture only to find your camera doesn't work because the battery's lost its charge. And if your child ever uses the camera, you have to be extra careful. Ben loves to turn my compact on and off as well as take pictures with it. But he usually leaves it on. And to make life harder, these batteries can be bought only at camera stores, so be sure to keep an extra supply on hand.

Other Cameras

Cameras don't all fall into the two groups I've mentioned, SLRs and compacts. You may have heard real photo buffs talk about medium-format cameras — cameras that give you a big negative — but they're extremely heavy and wouldn't be much use in taking pictures of children. The other two kinds of cameras that you might use are Polaroids and disposables.

Polaroid is a trademark for a camera that produces instantly self-developing photographs. In photographic terms, they resemble compacts: you can't control the focus or the exposure. The great appeal of a Polaroid is that it does deliver those instant pictures. Although I'd say a Polaroid shouldn't be anyone's first camera, it can be a lot of fun with a group of people. Children usually love them.

Disposable cameras obviously aren't going to be your everyday camera either, but they have some great features. For one thing, they aren't the ecological nightmare you might have thought. Kodak and Fuji both recycle them. Also, some of them take very nice pictures, especially the "panorama" model with a wide-angle lens. They come with surprising capabilities now: there's one with flash, one with a telephoto lens, and even an underwater version. This is an expensive way to take pictures, but it's a lot less expensive than taking an SLR to the beach and getting sand in the circuitry. It can also be a nice choice to give to an older child when you go on vacation. There's no way he can ruin it, and the photographs taken from his perspective can be a lot of fun.

The Ideal Camera

So what's the best kind of camera for taking pictures of children? There's no clear answer. I shot most of the photographs for this book with cameras and lenses that are at least ten years old. From a technical point of view, they are completely out-of-date, but they accomplish what I set out to do.

I've never bought equipment just because it was available, so naturally this is the approach I favor. Start simple. Work with what you have. Learn how to get the most out of your current camera. And then, if you find you're constantly frustrated by one particular shortcoming, you know what you need to overcome that. Say you're using your compact with automatic flash. You like to shoot indoors and in low light, but you don't like flash pictures. You aim for darker,

moodier shots, but the camera won't let you take them. That's when you get an SLR or a more advanced compact with flash you can turn off. On the other hand, suppose you have an SLR and you shoot outdoors a lot. You want to get close to your children and still be able to take in a lot of background. Maybe it's time for a 35mm lens.

As you take more and more pictures, you'll develop a sense of what you want them to look like. The best kind of camera for you is the one that will help you get those results.

Disposable cameras give you a chance to experiment with equipment that you wouldn't ordinarily use. This shot was taken with a "panoramic" camera, which has a wide-angle lens. It photographs more than your eye can take in, and it is very effective when you want to include a lot of landscape.

Film

To capture these boys on the slide, I positioned myself to frame the slide the way I wanted it and prefocused on the spot where the boys would be. Then I shot as they slid into the frame.

Have you ever gone to buy film and been overwhelmed by all the choices? Even the average drugstore or supermarket carries eight to ten varieties of 35mm film, not to mention cartridges and disks. Some carry several different brands. What's the difference between them? Does it really matter what you use?

There's a lot of difference, and it does matter — if you want to take the best possible pictures.

All film is basically a thin strip of plastic or polyester. It's coated with various chemicals, but the important coating is called emulsion, which is a light-sensitive liquid. This is the stuff that records your image. The other chemicals are there to improve the handling and stability of the film.

Naturally, you have to use the correct size film for your camera. Cartridges come in 110mm and in very limited varieties. Compact and SLR cameras use 35mm film (the number refers to the width of the film). Since 35mm film is available in so many forms, I'll break them down for you.

The Choices in 35mm Film

Black-and-White or Color?

The most obvious difference among kinds of film is this one. The emulsion of black-and-white film is one layer thick and records any image in shades of black, white, and gray. There are more layers to the emulsion of color film that record actual colors.

Chances are that you've been shooting in color. Color film is more readily available than black-and-white. And it records life as we know it. Children love color, and they tend to generate it. Their clothes, toys, art, rooms, are full of color — much of which would simply appear as midrange gray in black-and-white. Color film is also much easier to have processed than black-and-white. All those one-hour photo places and huge processing plants don't have

the ability to develop and print black-and-white film (which requires different chemicals). If you want to shoot in black-and-white, therefore, you'll need to take your film to an old-fashioned photo store or a full-service lab. It gets expensive, even though you can save money by having a contact sheet made first and enlarging only the best frames. A new black-and-white film made by Ilford, called XP2, is processed using color chemicals. You can take it to your usual lab and get prints back the same way you would with color film.

So why bother with black-and-white? One reason is practical: black-and-white prints don't fade. If you look at the photographs from your childhood, you'll see that often the color snapshots have started to look bleached while the black-and-whites are still sharp. Another reason to choose black-and-white is aesthetic, maybe even emotional: it has a strong, timeless quality. Color is a very recent part of photography, and many of the masterpieces of photography are in black-and-white. Shooting in black-and-white links you to the past. It's much more subtle, and when you have a spare, clean composition, it can be beautiful. You do have to remember that many midrange colors will appear as gray, so you need to shoot carefully.

If you are interested in developing and printing your own film, black-and-white is a good place to start. It is a much cheaper process to set up than color. The equipment can often be found secondhand, or you can rent time in the darkroom of a local photo club. Processing and printing allows you a lot more control over your prints. You can darken or lighten, increase or decrease the contrast to change the mood.

But then, if you're like most parents, a quiet hour in a darkroom is pretty unlikely. And you probably, like most parents, want color in your pictures. When shooting in color, you have another choice to make, as I describe below.

Prints or Slides?

Color film comes in two forms: **negative** and **slide.** Slide film, once it's developed, is positive. In other words, the colors and position of the image are correct after the developing process. Negative film gives you a negative version — the image is reversed and so are the colors. Negative films need to be printed onto light-sensitive paper to make the image correct.

The advantages of negative film (also known as **print** film) are obvious. You can look at prints without any fancy equipment. You can put them in an album, stick them on the refrigerator, mail them to Grandmother in Wisconsin. You can blow them up and frame them. Besides being widely available, print film is the cheapest form to process.

There's another, technical advantage to print film. It is more forgiving than slide film. Say you shoot your daughter trying on old clothes in her grandmother's shadowy attic. When you get the prints back, you see that you've lost some detail in the darker areas. It's possible to have the negative reprinted to lighten up those areas and retrieve the detail. But if you'd shot slide film, you'd be stuck with those underexposed areas. With print film there's room for error, while with slide film you have to get the exposure exactly right.

So why bother with slides? Color is one of the reasons. Slide film offers you the richest, deepest hues possible. Slides (which are also sometimes called **transparencies**) don't fade the way prints can. And some people enjoy showing their photographs in the form of a slide show (though in my experience these people aren't usually parents of small children). While you can have prints made from slides, the two-step process is very expensive, and only well-equipped labs can do it.

This series demonstrates the difference between different speeds of color film. I used ISO 100 on the far left. The grain is very small, which means the details are very sharp. The second shot from the left is ISO 200, and the difference between them is subtle — you can see a little more contrast in the second (look for brighter highlights on the hair) and slightly larger grain. The third shot from the left is ISO 400, and here you can easily see the stronger contrast. The darker colors, like the green bench and the red shirt, have more black in them, as do the shadows on the boys' skin. The grain is also much more apparent. The shot on the right, taken with ISO 1600 film, is very grainy. The contrast is also pronounced; the older boy's sneakers are dead white, while the shadows under the bench are nearly black. I shot this series on a hazy, low-contrast day. Bright sun and dark shadows might have made the 1600 shot impossible.

Which Film Speed?

Even after you have the color/black-and-white and slide/print questions sorted out, you still have to pick your film speed. This can be the most confusing part of choosing film.

Film speed refers to how sensitive to light the film is. "Fast" film is very light-sensitive; in other words, it requires less light to record the image. "Slow" film requires more light.

The ISO (also known as ASA, now a somewhat old-fashioned term) number on a film box refers to the film speed, and the lower the number, the slower the film. Film speeds as low as ISO 16 exist, but 64 is about the lowest you'll find outside of a well-stocked photo store, in either black-and-white or color film. The fastest film made now is ISO 1600, although 1000 is more common. Most older cameras require you to set the film speed manually, on a dial that ranges from 12 to 3200. Newer models use what's called the DX coding on the back of the film cartridge and set the speed automatically. The camera needs to know what the film speed is in order to calculate the right exposures.

So how do you choose? It depends on what you plan to be shooting. The brighter the light, the slower the film needed. In other words, for a sunny day at the beach most photographers would pick ISO 64 (which is usually slide film) or 100 or 200 print film. As I mention in chapter 1, "The Camera," this will give you the greatest flexibility in picking your shutter speed and aperture. If you use a high-speed film at the beach, slow shutter speeds or wide-open apertures might put too much light on the very light-sensitive film, and you'd have overexposed pictures. For low light, such as shooting indoors without flash, you'd want faster film, like ISO 400 or 1000. A good midrange choice is ISO 200. If you run out of film in the middle of a national forest, chances are the one film available at the nearest convenience store will be ISO 200 print film.

Your choice of film speed can affect the appearance of your photos in another way. The light-sensitive chemicals in the emulsion are in the form of tiny particles. In slow film these grains are minute, and they are virtually invisible in the finished slide or print. But in faster film, the particles are bigger. You can see them, especially in enlargements. The coarser grain is one of the drawbacks of shooting with fast film, but most photographers who prefer not to use flash accept it.

Color Balance

There is one more variable in different kinds of film — color balance. Our eyes are so accustomed to different kinds of light that we hardly perceive them. But ordinary incandescent light bulbs, which are known to photographers as tungsten light, have a pronounced yellow cast, while fluorescent light has a greenish tone. Most print film is balanced for daylight: that is, when it's shot in daylight (or using flash, which comes close to replicating daylight), the colors are correct. But because it undergoes two different processing steps, print film can be corrected if the color balance is off. For instance, if you're using ISO 1000, you may be tempted to shoot in your living room with the lights on. Since the film is balanced for daylight, the prints will come out with a yellowish tone. However, if you alert a custom lab to this, they can correct for it in the printing process and the colors will be true.

Slide film is trickier. Because it undergoes only one step in the processing, it can't be corrected that way. So most slide films are balanced specifically for daylight or tungsten light.

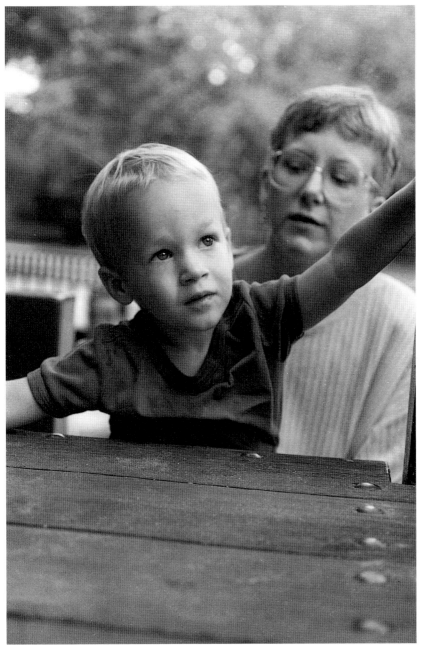

Black-and-white film has the same speed characteristics as color. This was shot at ISO 100. The light on the boy's face is very even, and the grain is barely visible. The picture is mostly mid-gray tones.

Brand Equivalents

As if all these variables weren't confusing enough, there are also lots of reliable manufacturers that produce film. Kodak is the most widely available, but you may also find yourself pondering brands like Ilford, Agfa, Fuji, and Scotch, or even chain-store brands. They all make similar claims of quality, and many of them make comparable products. In other words, if you want ISO 200 print film, you have your choice of many brands. The chart on the page opposite will help you see which brands offer similar performance.

Taking Good Care of Your Film

The suggestions below are for all sizes of film, not just 35mm. If you follow this advice about storing film, choosing among different-dated film, loading film, and handling it while you're traveling, you're well on your way to good results.

Storage

First, a couple of don'ts. Don't keep film where it might be affected by chemical vapors. You may think you don't have those in your house, but lots of cleaning supplies contain ammonia or other strong chemicals. True, most people don't store film under the sink. But you also need to be aware of such products as rubbing alcohol, witch hazel, or nail polish remover, which could affect film.

Heat is another problem. Try not to leave film in the car in summer, and don't put it in the glove compartment. Think of it as a little bit prone to spoilage, like a chicken. You need to get it home and into the refrigerator pretty promptly — don't stop at the pool for a swim on the way home.

Yes, the refrigerator. Manufacturers state that their film is stable until its pull date (the date on the carton) and that you don't need to refrigerate it. But if you keep it in the box and put the box in a plastic bag (to keep it safe from leaks), it will last longer. Because your refrigerator maintains a low-heat, low-humidity environment, it can prolong the life of your film. Many photographers keep their film in the freezer, which extends its life even further. Just remember to bring the film out an hour before you need to use it, to let it come to room temperature.

Age

It's unlikely that you'll buy film that's too old to shoot, but make a habit of checking the date on the box anyway. If you have a choice between film that expires in a year and film that expires in two years, get the fresher box. There's less chance that it's been stored badly or mishandled. (Try not to buy film that's been stored in a shop window, for instance, or anywhere else where direct sun could have fallen on it.)

To get the best from a roll of film, you should process it as soon as the whole roll is shot. Try not to leave half a roll sitting in the camera, either. Sometimes you can't avoid this, and I wouldn't suggest that you shoot aimlessly just to finish a roll. Keep in mind, however, that the images you've shot do start to deteriorate without prompt processing. They won't be awful, but they won't be as good as they could be. If you can't remember when you last loaded your camera, don't expect miracles when you get the roll developed.

Film Handling and Travel

The new automatic cameras have made loading a lot easier. It's not necessary with the new models to carefully fit the holes onto the sprockets and wind the film with the back open. These days it's much less likely for new camera owners to think they've shot a whole roll, only

Film Choices and Characteristics

Color Print

Speed	Kodak	Fuji	Agfa	Ilford	Scotch	Description
100	Kodacolor Gold	Fujicolor Super HRII	Agfacolor XRG	N/A	Color Print 100	For use in bright sunlight or with electronic flash
200	Gold	Super HG	XRG 200	N/A	Color Print 200	For use in moderate sunlight or hazy day conditions or with flash indoors
400	Gold	Super HG	XRG 400	N/A	Color Print 400	High speed for indoor/outdoor use
1000	N/A	N/A	N/A	N/A	Color Print 1000	For use in many existing low-light conditions, indoors and outdoors
1600	Gold	N/A	N/A	N/A	N/A	Similar to 1000

Black-and-White Print

Speed	Kodak	Fuji	Agfa	Ilford	Scotch	Description
125	Plus-X	N/A	N/A	FP4 Plus	N/A	Medium speed, fine grain
400	Tri-X	N/A	N/A	XP2	N/A	Fast film, for use outdoors
1000	N/A	N/A	N/A	N/A	N/A	Fast film, for existing light conditions

Slide

Speed	Kodak	Fuji	Agfa	Ilford	Scotch	Description
50	N/A	Fujichrome RF	N/A	N/A	N/A	Slow film, good in bright sunlight
64	Kodachrome	N/A	N/A	N/A	N/A	Fine grain; crisp, sharp colors
100	Ektachrome	RD 100	Agfachrome CT	N/A	Color Slide 100	Medium speed for bright light or flash
200	Ektachrome, Kodachrome	N/A	CT 200	N/A	N/A	Both work well indoors with flash
400	Ektachrome	N/A	N/A	N/A	Color Slide 400	High speed for low light
1000	N/A	N/A	N/A	N/A	Scotch Chrome	Use with existing light conditions

to realize that the leader slipped off the reel and they didn't shoot anything. If you can, though, try to load your camera in subdued light.

Most cameras are pretty frequent fliers, and airport security checks pose a threat to your film. I know they say that the X rays don't harm film, but the effect of these detectors is cumulative. On high-speed film, it can cause problems. The film is fogged and the color can be affected. You can either have your film hand inspected (show up early or you'll have a lot of impatient passengers piling up behind you) or put your film in lead-lined bags from a photo store and pack them in your checked baggage. If you're traveling from country to country, you might want to have the film processed abroad rather than having it repeatedly zapped. On the other hand, if you have children you're not likely to be traveling from country to country, are you?

Protecting Your Pictures

If you go to considerable trouble to handle film carefully and take the best photographs you can, it's worth putting a little bit of extra time and money into developing and storing them. Your first step should be finding a reliable film processor, and this won't usually be the corner drugstore or the one-hour photo drop at the supermarket. The quality can vary widely. I believe it's worthwhile to cultivate a relationship with a nearby photo store. They can develop film in black-and-white, take care of your enlargements, and handle special requests like correcting color balance. Another alternative is one of the large mail-order film processors, which tend to be reliable and reasonably priced.

Once you get your pictures back, your first step should be to separate the negatives and carefully slip them into protective sleeves (which are available from photo stores). Negatives are the source of your pictures, so they should be handled as little as possible, and with great caution.

Slides deserve the same kind of care. They can be stored in pages of clear plastic sleeves. You can get these with holes to store in ring-binder notebooks. It's also fine to keep them in slide carousels, if you keep the carousel covered in a cool, dark, dust-free place.

Prints can be treated a little more casually. Fingerprints can be wiped off them with a tiny dab of rubbing alcohol or lighter fluid on a cotton swab. If you need to mark a print on the back, write very lightly with a permanent felt-tip marker. Other kinds of ink are likely to rub off, and if you stack prints on top of each other, the writing on the back of one will turn up on the front of another.

I know most people feel it's impossible to throw away an image of their child, but some pictures really don't need to be kept. If you have shot some that are out of focus, are tilted, or show a face you'd just as soon forget (every child makes them sometimes), be brave and pitch them out, slides or prints.

On the other hand, you will sometimes shoot pictures that are so great you want to blow them up. Be aware that enlargement emphasizes the weak points in a photograph — if the focus is not very sharp or the composition is clumsy, these flaws will be more obvious in a bigger image. What's more, faster films like ISO 400 and up often give you grainy enlargements, and the larger the reprint, the more striking this is.

If you are very happy with a picture and plan to display an enlargement in a frame, I'd suggest having two prints made of the enlargement. Keep one in a safe place and frame the other. Exposure to daylight will eventually fade most color photographs, and this way you'll keep one image pristine.

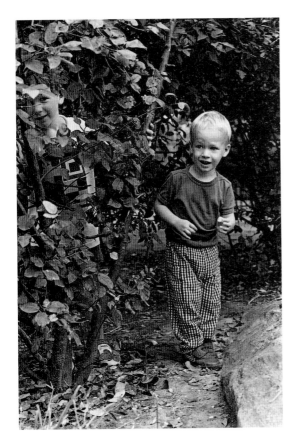

Unlike the picture on page 25, this one was shot with ISO 400, and it's easy to see both the grain and the higher contrast — the highlights are lighter, the shadows darker.

Daylight isn't the only destructive factor. Many framing materials can also hasten the deterioration of photographs. Those simple plastic box frames with cardboard backing, for instance, can be a problem, since acids from the cardboard and chemicals from the plastic break down the photograph.

Most people put a few prints in frames, send some to relatives, and put the rest in albums. Lots of album pages unfortunately contain a material called polyvinylchloride (PVC), which destroys the color in your pictures. It is worth investing in pages made of Mylar or polypropylene and transferring your pictures to them. These pages are a little more expensive and harder to find, but they're a worthwhile investment. Look for album pages — and framing materials — that are labeled "archival." This means that the products contain no acids or chemicals that will break down your pictures.

Putting your pictures in albums can be a terrible chore if you get backed up, but it can also be a creative way of capturing your experiences. I have a friend who puts together albums using the little black corners that you glue on the page (which, by the way, are a good way to preserve prints). She writes long descriptive captions under each photograph, and the result is a work of art. I've also seen parents who vary albums by tucking in brochures, ticket stubs, pressed flowers — anything flat enough to fit on the page.

These suggestions may seem elaborate, but they involve only a small investment in extra time and money. Taking good care of your pictures can become part of your photography routine. Sooner than you think, when your children start showing your photographs to *their* children, you'll be glad you made the effort.

Chapter 3
Light

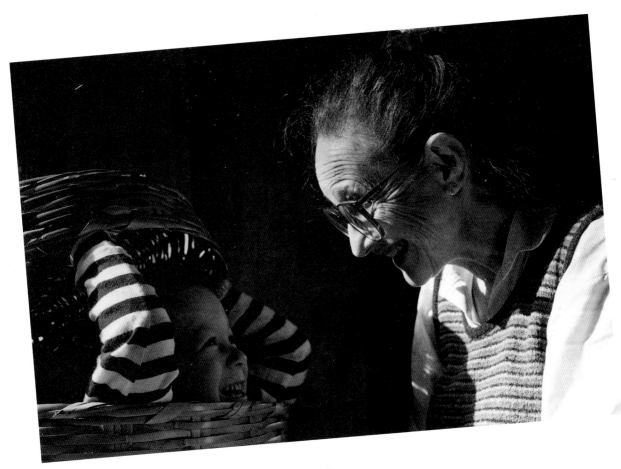

When my mother brought this basket in from the car, Ben immediately climbed into it. The strong light was coming through the open door, and I shot quickly to capture this warm interaction between my mother and my son.

Light is such a basic part of life that we tend to take it for granted. When was the last time you noticed the light and shadows around you? As a photographer, you will come to realize that light is one of the most important components of your pictures. This is true not only because you couldn't make an exposure without light. Light, and what the photographer has done with it, can make images magical.

Light can set the mood for a photograph. Think of the drama of a brightly lit face emerging from deep shadow, or the idyllic feeling of a scene shot in sun-dappled shade. Light gives a sense of time and place. The cool, slanting light of northern areas is very different from the brilliant direct sun of the south, for instance. Light helps complete the statement you're trying to make, and beautiful light can make a picture extraordinary.

It also conveys a lot of information. Take a look at your face in any mirror. Notice the shadows and bright highlights. They are what give your face a three-dimensional look, or modeling. Without the darker and lighter areas your face would look flat, because even if we aren't aware of it, we rely on shading to tell us about the shapes of things.

Now change the light on your face: turn on a lamp or get closer to a window. Notice how different the shadows and highlights are. Which is more flattering? Which would make a better picture? This is the kind of awareness that you can cultivate, and it will improve your pictures enormously. I think that skillful use of light and intelligent composition are the most important components of superior photographs. Training your eye to recognize a good composition can take time, but once you know what to look for, recognizing good light is simple.

All light, whether it's sunlight or light from a flash, has certain significant qualities: direction, intensity, and color. Alertness to these qualities is the first step to judging lighting conditions.

Usually it's a mistake to light a subject from behind, but in this case I was struck by the way the sun turned Albee's hair into a halo. I made sure the camera metered for his skin, which made his hair turn white.

Direction simply means where the light is coming from. If your child is standing next to a sunny window, one side of his face will be highlighted and the other will be in shadow. If he's outside at high noon on a sunny day, the light will be overhead, and he'll have shadows under his nose and his chin. And if his back is to a light source, his whole face will be in shadow. If the light is coming strongly from one direction, you need to be careful about how it casts shadows. Unless you're aiming for a specific effect, you may want to move your subject or change your position to find more flattering light. Side lighting is usually the best choice for a portrait.

Intensity means brightness. Intense light will give you bright highlights and dark shadows. We also call this high contrast (remember the contrast button on those old black-and-white TVs?). Most photographers prefer softer, more diffused light.

If light is too strong, you lose some of the detail in your picture. Only the most sophisticated cameras can accurately expose for a wide range of bright lights and dark shadows. In a high-contrast situation, if the shot is exposed to show some detail in the shadows, the highlights will bleach out to white. But if the highlights are exposed to show detail, the shadows will fill in with black. This is the kind of lighting situation you want to avoid.

In some ways, actually, overcast days with some sun give you the most flattering pictures of people, because they provide plenty of light for soft modeling but not so much that the shadows are harsh.

Color is another point that we sometimes ignore. We think of daylight as being white overall, but anyone who's taken pictures when the sun is setting knows that it can be golden or even reddish. Fluorescent and incandescent bulbs have pronounced green and yellowish casts, respectively, which will show up in your photographs. And light reflected off something bright will take on that color. For instance, if you take pictures in a room with direct sunlight on a red carpet, the light will have a pink cast. Your eye is used to the tone and doesn't perceive it, but the camera does. You need to be aware of it, too.

All Natural

There are basically two kinds of light, natural and artificial. Natural light is what comes from the sky, either direct sunlight or sun diffused by clouds or slanting through a window. Artificial light is what the photographer adds. I'll take natural light any day. Almost all of the pictures in this book were taken in natural light, even many of the indoor shots. You get a lot more subtlety with natural light.

But there's a lot of variety in what the sun does. Certain times of day make it easy to take good pictures; others present difficulties. Here are a few situations and how to adjust for them.

This was shot in summer, after the sun had gone down. The dramatic shadows of sunset have vanished, and a warm light is wrapped softly around the subject's face.

In this shot Ben is on his way outside right after a rainstorm. The sun broke through at the end of the day, making the wet deck gleam. I could have exposed for Ben's skin here and let the shining deck go white, but I preferred this moody silhouette.

Beginning or End of Day

These are my favorite times to shoot. The shadows are not quite as deep as during the middle of the day, because the sun is striking the earth at a severe angle and the light is thereby diffused.

Depending on how much haze (or smog!) there is, afternoon light can be even softer and more golden than morning light. Because the light is so diffused and quite even, it's easy to get good exposures. You may even find a shaft of light indoors for a dramatic photo. This is a little harder to expose; make sure the camera is metering for, or reading, the highlights and not the shadows. With an automatic camera you do this by pointing the lens at the brightest part of

the picture to read the exposure. Then press the shutter button halfway down to hold that exposure and move the camera to recompose your shot. If you meter for the shadows instead, the camera will provide too much light, and the highlights will be overexposed. To shoot regularly in early or late light, keep your camera loaded with a fairly high-speed film, like ISO 400 or above.

High Noon

This is the time when most of us are out there with our cameras, at picnics and beaches and parks. But it's actually the worst time to get good photographs. The light is very bright and casts deep shadows. If you position your subjects facing the sun, they squint. It's a little better with the sun behind them, though their faces will be shadowed. This is called

The outside light illuminates the backs of these two girls playing dress up, as well as their reflections in the mirror.

backlighting, and one way to compensate for it is with flash (which I discuss later in the chapter). There are other ways to handle bright midday light. Put the subjects in some kind of shade — under trees or a pale umbrella — to diffuse the light. Or try to reflect some light back onto their faces by putting a white T-shirt or towel on the ground. You'd be amazed how well this can work to lighten up shadows. When you're shooting at midday, be very careful to watch children's eyes, because hard shadows can black them out — you get the prints back and the children have dark eye sockets. The best film for situations like this is ISO 100 or 200, which is low-contrast. Bright midday sun will provide enough contrast on its own.

Cloudy with a Chance of Showers

People rarely go outside on a hazy day and say to themselves, "What a gorgeous day to take pictures!" In fact, you can get better pictures on a day with iffy weather than you can when it's very sunny. Haze cuts the contrast of the sunlight. There are no deep shadows, and the light wraps around faces. It doesn't leave hard lines. While there's enough shadow to give things a three-dimensional look, it never obscures anything. You have a lot of freedom in terms of position, because you don't have to worry about dark shadows blacking out the children's features.

Pictures on a rainy day can be wonderful, too, since children's rain gear is usually brightly colored and looks very cheerful. But you have to be very careful about keeping your camera completely dry.

If you're going to shoot on a day without much bright light, use ISO 400 film, and flash might even come in handy as the light dies at the end of the day.

Indoors

Yes, you can shoot without flash indoors. It depends on the weather and the time of year and how your windows are placed, but you can do it. You'll need faster film, like ISO 400 or even 1000. And you'll have to be careful about the direction of the light. Remember, if the children are between you and a bright window, they'll be backlit and your photo may be just a silhouette. Try to move around so that you stand between them and the primary light source. (Then watch for your own shadow!) You can sometimes improve the light in a room by moving a lamp or taking off a lampshade, especially if you're shooting in black-and-white. But if you're shooting in color, remember that ordinary household lamps with incandescent bulbs give a yellow glow on daylight-balanced film.

Shooting with Flash

Of course, there are times when the available light just isn't adequate — at night, or indoors, or on a cloudy day. That's where flash comes in. I tend to look on it as a necessary evil. Sometimes you need it to make shots possible, but it has serious drawbacks. One is that you can't know in advance what your shot will look like. Basically, flash is a burst of white light produced by your camera. It illuminates the scene for an instant while the shutter moves. You have the camera up to your eye as the flash fires, and it's so quick that you can't judge the picture until you get it back from the processor. For me, this is a big problem. With different kinds of cameras and flash attachments, you can more or less get control over the direction and intensity of the light. However, there are still going to be surprises. This is why professional photographers invest a lot of time and money in studio lighting equipment.

Fast black-and-white film can be your best choice for shooting indoors when you don't know what the lighting conditions will be. The lights in this room were fluorescent, which would have given a greenish cast on color film.

The reason there is no red-eye in this picture is that the camera was well below the level of the baby's eyes.

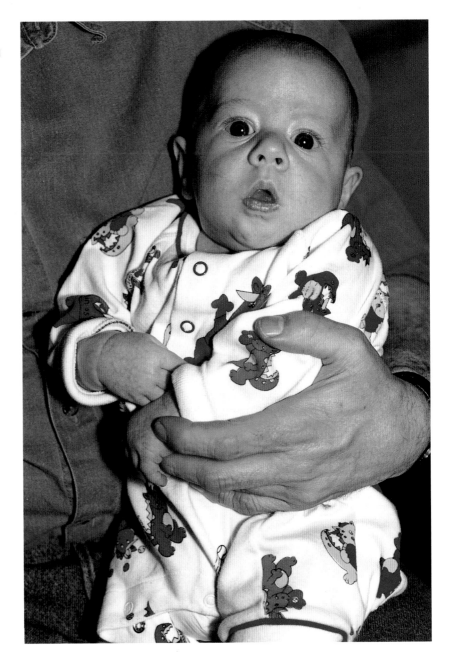

But even if you had unlimited funds, setting up lights to photograph the unpredictable movements of children would be useless. Flash on the camera is therefore sometimes necessary.

Compact Camera Flash

With most compact cameras, you don't have much control at all. Sometimes the flash on my compact will surprise me by going off even in the outdoors. But the lenses of most compacts are not very fast — the maximum aperture is usually about 3.5. So in situations that would be adequately lit for an SLR with a maximum aperture of, say, 1.8, the compact has to resort to flash. Some of the more sophisticated compacts do have options that let you turn the flash off. Some even have a very handy fill-flash option, which fires the flash at half power when your subject is backlit. This puts some light on the face yet doesn't overpower the natural light.

There are two important things to remember when you're using a compact and expect to need artificial light. One is that you should always shoot negative film with a compact. Slide film demands real exposure precision, and compacts simply can't provide it. I shot a birthday party with slide film recently, and half the slides were overexposed, the other half underexposed. I won't make that mistake again.

The second consideration when using a compact in artificial light is to avoid overshooting your flash. Your manual will tell you what distance your flash will illuminate; it's usually between 10 and 15 feet, which isn't far. If you're sitting in the audience at a school play, for instance, your flash will not reach the stage. Sometimes I sit in my apartment at night and watch the flash cameras going off at the top of the Empire State Building as tourists try to take pictures of New York City. They won't get anything back on their prints besides little pinpoints of light on a black background, because their tiny flash can't illuminate what's far away.

Also, the flash on compact cameras has two real drawbacks. One is the harshness of the light. It is so bright and intense that it sometimes washes out modeling and detail. The shadows can be very strong, too, especially if you're indoors shooting against light walls. Unfortunately, there's nothing you can do about the quality of the light. The other big problem is red-eye. I'm sure you've seen plenty of pictures of people looking cheerfully at the camera, with red eyes. This effect is caused by the iris of the eye reflecting light from the flash back into the lens. The best way to avoid it is to physically separate your light source — the flash — from your lens and thus prevent the light reflected from the subject's eyes from glaring into the lens. But you can't do this with a compact, where the flash is fixed. All you can do is try to position yourself so that you aren't on a line with your subject's eyes. Try to get below them or above them.

There is another trick. It won't fool everyone, but it will improve your pictures. You can retouch the red-eye at home. Take an extra-fine-point plastic pen and make tiny dots on the red part of the eye. Leave a little white catchlight on the pupils. (Practice this first on a print you're not crazy about.)

This shot illustrates the limited range of most flash units. I was about 15 feet from this girl, and though she's lit perfectly, the boy behind, who was only about 2 feet farther away, is quite dark.

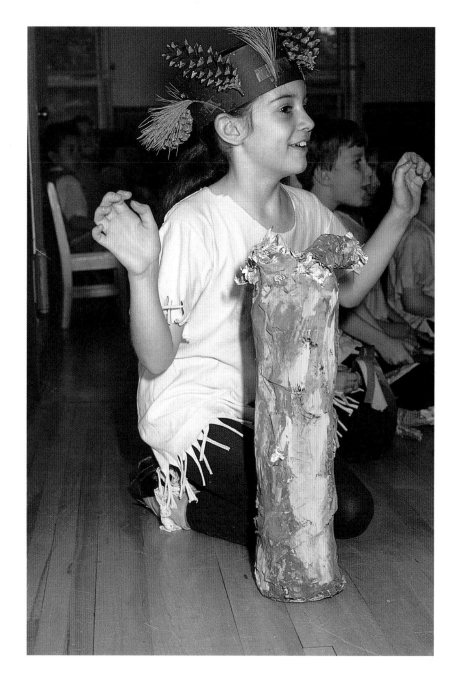

Flash with an SLR

At least with a compact camera you don't have to worry about learning how to use your flash. I have to admit that I rarely use a flash attachment on my SLR, because I find it intimidating. But the new technology has made it all a lot easier. And with an advanced flash attachment, you can get pictures that would be impossible otherwise. The greatest recent technological development has been through-the-lens (TTL) metering. This makes it possible for your flash attachment, electronically communicating with your camera body, to measure the amount of light that comes directly through the lens. Using the camera's computer, it can calculate and set the correct aperture, flash power, and duration. With the most up-to-date systems, you can just pick the camera up, turn it and the flash unit on, and shoot confidently.

Of course, many of us are still using older cameras without all that microchip circuitry. There are plenty of flash units available that are compatible with these cameras. Most of them incorporate a sensor system that turns off the flash power when the subject has received enough light. (This sounds slow and clumsy, but remember how fast light moves.)

The simplest flash systems — though not the simplest to use — are manual. They produce light of a certain intensity, and you have to set the aperture of your camera according to how far from the subject you are. Most of them incorporate a dial or graph that you can read to get the right aperture for your distance. (Don't worry about losing depth of field, since the background will be darker anyway and you want your subject to stand out a bit.) You also have to be sure to set your camera to the correct synchronization speed. This is the fastest speed at which the shutter is fully open when the flash fires. You can shoot with flash accurately at any speed slower than the sync speed, but under 1/60 second things will blur and the incandescent light in the room will record on the film. (If you forget and shoot faster, you'll get a partial picture because the shutter won't be fully open as the flash fires.) The sync speed is usually marked on the shutter speed dial with an X or a lightning bolt. On older cameras it could be as slow as 1/60 second, which means that you can't capture much in the way of movement with flash. On the newer models the sync speed is usually 1/125 or even 1/250, but on the newer cameras the computer will usually set it for you.

If you're in the market for an SLR flash, I strongly suggest that you get the most powerful, most advanced one you can afford that's compatible with your camera. This is a situation where it's really worth spending extra money. I also recommend getting a flash unit with a movable head, so that you can bounce light off the ceiling. I'll get to that in a minute.

There are so many different kinds of flash that I can't tell you exactly how to make the most of your unit. You need to read the instructions carefully. Using flash successfully requires experience. Try shooting a couple of rolls experimentally, paying close attention to the results. One thing to be aware of is that your subjects should all be roughly the same distance from the flash, because its power diminishes sharply with distance. If you shoot two people, one of whom is 3 feet away and one of whom is 5 feet away, one of them will probably be over- or underexposed.

Flash on an SLR has the same drawbacks as flash on a compact camera: red-eye and harshness. But with a separate flash unit, there are some remedies. One of the most straightforward ways to avoid red-eye is to move the flash away from the lens of the camera. You can do this with some flash units by using an armlike attachment that holds the flash. Or you can connect some units to the camera body with a cord and hold them away from the camera, shooting with one hand. This takes some practice, as you can imagine, but the results can be very good.

Another common technique, called bouncing the flash, takes care of red-eye and also softens the light. If you have a flash unit with a movable head, you can aim it at the ceiling. The light bounces off the ceiling and washes over your subjects in a more diffused, softer way. The shadows aren't as harsh, and they fall in places that look more natural to us (under the nose and chin) because we're used to the sun's illumination from above. You can even ricochet the light a couple of times by using the ceiling and a reflector (or a white towel) on the floor. One of my assistants is an expert at this, and he likes to bounce light all over a white room, like a billiard ball caroming off the sides of a pool table. The important thing to remember in bouncing light is that you have to account for greater distance from the subject. You may be only 8 feet apart, but if the light has to move from a camera 5 feet off the ground up another 3 feet to the ceiling and then down to the subject, you need to factor that in when selecting the flash power. This takes some practice, too.

I mentioned fill-flash in connection with compact cameras. If you're using flash as your secondary source of illumination, to fill in shadows, you don't want it to overpower the primary source — i.e., the sun. Some of the new, elaborate flash units allow you to select your ratio of flash to daylight, but that's unusual. Most units with TTL metering will automatically assess the need for fill-flash and provide the right output. You need to set an older unit to give you less power. Thus, if you're 10 feet from your backlit subject and you want fill-flash, you set the unit as if you were much closer.

There are a lot of other ways to try to control artificial light. Photo stores are full of light banks and reflectors and umbrellas and other equipment. I am not going to get into any of those options here, because I don't think most parents have the time to deal with them. If you are interested in learning more about different light sources, look for books and manuals that deal with the subject in most photo stores.

You're never supposed to place your subject facing into bright sunlight, because he or she will squint and your shadow will appear in the picture. This dramatic shot is the exception that proves the rule: the sun is so bright that Edward is trying to hold his eyes open with his hands, and my shadow looms next to him on the wall.

The Subject

Music is often a good way to distract or relax your subjects, whether they're babies or adults. I shot this with a compact camera that has a 35mm lens. That accounts for the distortion — notice the difference in the size of Ben's hands.

78-28

So far I've talked about the technical elements that all of photography shares: the camera and the film, and how light works on them to make a picture. But as someone who photographs both still lifes and children, I can tell you that children make special demands on the photographer. A bowl of apples is easy: if one of them is in the wrong place, you pick it up and move it. Just try that with a two-year-old!

This contact sheet shows some of the phases you go through in a portrait session. In the bottom right frame, I started out at some distance from Edward, then moved in.

He was still quite hesitant, and most of the shots are full of his doubt about the whole thing. But by the bottom left-hand frame, he was interacting with me and gradually broke into the smile, top left, that I was waiting for.

45

If you're going to take good photographs of your children, you're going to have to direct them somewhat. Even dangling a rattle in front of a baby's eyes qualifies. You may not know yet what kind of photographer you're going to turn out to be. Some of us tend to be shy, inclined to sit back and watch and to grab shots as they come. And some of us get very involved, talking to kids from behind the camera, making suggestions and jokes, trying to draw out the expressions we want. Some of us like to shoot candids, capturing moments as they occur. Sometimes it's fun to make picture taking more of a production, using props and even costumes. These are all possibilities, and as you shoot you will find what makes you most comfortable. Just remember that if you aren't at ease, the children won't be either. So if you're the more reserved type, don't try to direct kids too much. Ideally they'll know you're there, but they will forget about the camera and act

naturally. That's what we all aim for. I can add from my own experience that the more often you take pictures of your child, the more accustomed to cameras he or she will be. By the age of two Ben was a real veteran, and now even in artificial situations he's completely relaxed.

Dressed for the Occasion

An example of a rehearsed situation is having your kids sit for a series of portraits. Parents usually do this for a holiday card (see chapter 11, "Portraits," for details), and if there's one occasion when you want your children to look presentable, it's for a picture you're going to send to all your friends and relatives.

There are a couple of important points here. Don't branch out too much. If your sons spend their days in sweats and T-shirts, don't put blue blazers on them for the photo session — they'll feel awkward, and it will show. If you plan to have them wear new clothes, run the clothes through the wash first to take out any stiffness.

Posed pictures don't have to be self-conscious. This boy was so excited about rolling in the sand that he didn't care about the camera. That gave me time to carefully center him against the simple background, making a striking composition.

Whether to dress them exactly alike is up to you, but it is a good idea to maintain some similarity. You could stick to a basic color scheme, like red and blue. Or you could dress everyone in similar clothes, like blue jeans and turtlenecks, and the colors won't matter so much. I would suggest staying away from patterns and brilliant colors if possible, since they can dominate a photograph so easily.

Props are another issue. I like using hats. Since they often signal a profession or occupation, they're great for preschoolers, who enter into fantasy so readily. Give your child a baseball cap to wear and suddenly you have a four-year-old baseball player. Sometimes putting a hat on a child brings out great expressions. You might see bravado, pride, or

Bubbles are a guaranteed icebreaker for smaller children. I shot this at a wide aperture and let the brightly lit grass behind the subject fade into a blurry background.

just shy pleasure as she tries out how the hat feels, what it's made of, and what it signifies.

Photographers who work a lot with children often have a supply of similar things that can break the ice with kids. Musical instruments, bubbles, stuffed animals, will all capture a young child's attention. But you have to be careful that the prop doesn't overwhelm the picture aesthetically. A giant Sesame Street doll,

for instance, could dominate a photo of a toddler. And you also have to be sure, as you compose the shot, that the prop "reads" clearly. In other words, you don't want to look at your picture and wonder, "What is that in Toby's hand?"

In the Background

As a rule, you should try to get close to your subject. If you shoot tight, filling the frame with your child's face or body, you'll simplify your composition and eliminate any distracting background. There are times, of course, when the background is also part of your shot.

To get a good picture of your child dressed up, try to capture a moment when she is feeling comfortable and relaxed.

Naturally, if you're on vacation, the locale is important. And sometimes your background provides essential information. If you're shooting your child's school birthday party, you may want a few tight shots of candles on the cake, but you also need some wider shots that show the other children, the teachers, and the surroundings. Not all of the pictures you take are going to be art shots. Some of them are simply reporting — "This is what Joey's first-grade class looked like." When this happens, the subject may not be so much your child as your child's classroom. This kind of situation makes for a shot that's more complicated, and certainly busier. You may have to work harder to compose it. For instance, look for ways to turn the background into a pattern. And remember, if you are including the background in your shot, you may want to close down your aperture a little to get more depth of field.

Age-Appropriate

The background isn't usually what presents the challenge in photographing children, however. It's the children themselves. Any mother will tell you that getting a child to cooperate demands different strategies for different age groups. Taking a child's picture is like getting her to eat her vegetables in that respect. What works for a toddler is useless for a school-age child.

Toddlers

Because they are unself-conscious, toddlers can be very rewarding to photograph. They are also still at a stage that can be incredibly cute. (Sorry, there's no other word for it.) But getting a toddler to do what you want him to is a real challenge. As a photographer, you have a choice. You can either try to psych him out and lure him into cooperating, or you can just go along for the ride and shoot what comes up. I've tried both, depending on what seems to work best for that child.

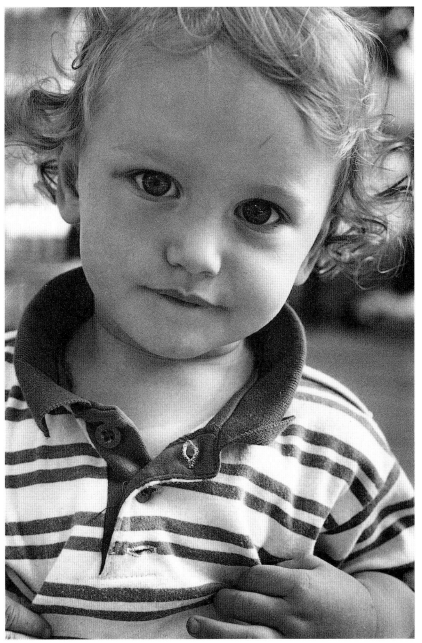

I was shooting at a playground when I met this little boy, and to get rid of the distracting background I moved quite close to him, crouching to put the camera at eye level. I wanted to be sure to capture the slightly nervous gesture of plucking at his shirt, so the photograph cuts off a bit of the top of his head. I like the way he more than fills the frame.

Preschoolers pretend at the drop of a hat. This tube appeared in the playground and, during the hour I spent shooting there, became a sword, a telescope, a megaphone, and a bat. Notice how Willy is holding it perfectly horizontal, echoing the lines of the climbing frame.

A camera with automatic focus can be a real help when you're shooting toddlers, because they move so erratically. Not many of them will hold a position while you fiddle with a focusing ring. And a special hazard is the stage when they always try to grab for the camera. Giving a two-year-old a toy camera to fiddle with while you shoot can be a good strategy unless he sticks the camera up to his eye to copy you for the next half hour. I've seen it happen.

Preschoolers

This is the age of the fake smile. It sets in around three, and it sticks around for several years. Preschoolers also like to pose in various stiff positions, mostly to show you that they can. It takes a lot of talk from the photographer to make them forget about posing and just act natural. The enjoyable things about preschoolers are that they've become extremely verbal and they actually like to cooperate. You can get a child to open up by discussing her preschool or her siblings, her dolls, her favorite videos, her pets. I've found that tongue twisters send them into giggles, which loosens them up beautifully. It is not unrealistic to ask a four-year-old to sit still. If you suggest he turn his head and look at you, he will.

Preschoolers enjoy having their picture taken, and they adore the results. If you've ever wondered what to do with all those prints that weren't quite worthy of the photo album, give them to a child, who can cut them up, put them in a book, send them to friends. The healthy egotism of children this age allows them to enjoy looking at photos of themselves for hours on end.

You have to remember that for some school-age children, time spent being photographed means time not playing. The way to guarantee willing subjects is to shoot while they're doing what they enjoy.

School Age

By the time children are in kindergarten or grade school they're old enough to concentrate on something, even if there's a photographer around. They'll smile naturally for you, show off a project they've worked on, and be great subjects — except when they don't feel like it. And when the sulks set in with this age group, you won't be able to coax them out by producing a balloon or a sheet of stickers. It takes more work than that. Another problem can be the sillies. All it takes is one child sticking out her tongue at the camera to make it an epidemic. You have to play this one by ear. Pleading is no good, and I don't think trying to command is, either. You might try turning things around by handing your camera to one of the kids. Most automatic cameras are simple enough for a six-year-old. I find taking turns with the camera helps; the photo session suddenly becomes a cooperative event.

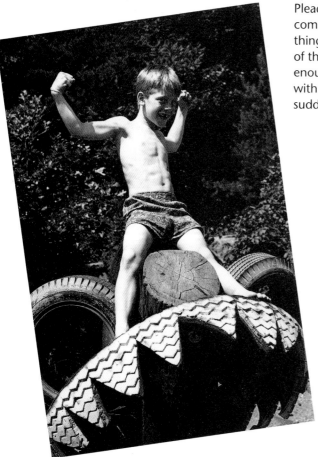

Your subject is not just a child's body but also his personality. James Phillip's triumphant stance atop the tire sculpture perfectly communicates his daredevil, athletic nature.

School-age children still like to dress up, provided they can be cool at the same time. Sunglasses work well, and so do adult hats, but anything that even hints of nursery school will freeze them.

Older children don't let everything show as much as the little ones do, so your photos may be a little subtler. A camera with an excellent lens can be an advantage here. The SLR that you took on your honeymoon and abandoned when you had children might be worth dusting off once they reach the rational years.

Here's one shot where a case of the sillies was turned to good advantage. These siblings look even more alike with their tongues sticking out.

Teenagers

And then you might want to put a telephoto lens on it and hide in the bushes to get photographs of your teenagers. The self-consciousness of the preschooler comes back ten years later. But where the preschooler happily makes a stiff face for the camera, as a teenager she'll slink away or hide behind a curtain of hair.

Personally, I hate looking at photographs of my teen years, but my parents don't feel that way. I know they're glad to have the pictures. The problem is that every time you approach a teenager with a camera he'll say, "Don't take my picture!" So you need to treat him like a shy animal in a game park and either catch him unawares or distract him.

I think this shot perfectly captures the average teenager's reluctance to be photographed, and the typical props of her leisure time. You don't need to see your subject's whole face for a photograph to work.

Sometimes the best prop of all is a baby.

Professional portrait photographers sometimes like to shoot their subjects when they're involved in a hobby. This relaxes the subject and can also provide some interesting information. It's a good way to approach a shy teenager, too. Another tactic is to shoot teenagers in a group, because they can lend one another bravado.

With a Parent's Eye

One of the hardest things for a parent to learn is to see her child as a subject rather than as a child. When you look through the viewfinder you aren't seeing what you *see:* you're seeing what you love. Let me give you an example. When Ben was a baby I took dozens of pictures of him sleeping. They all look alike — he's lying there in the crib with his eyes shut. Now, I know why I took those pictures; there's something really irresistible about a sleeping baby. Every parent feels it, and because I'm a photographer I wanted to photograph it. Like most parents, I wanted to capture what was happening.

Photographs are often primarily mementos. A lot of us take pictures as a way of trying to hang on to our children's youth, and that's fine. But I went overboard.

I'm not suggesting you take fewer pictures. After all, what we really regret are the pictures we missed, not the pictures we took that didn't turn out to be very interesting. But I do think it's important to develop the instinct that says "That would make a great picture." Here your impulse to shoot is visual instead of emotional. And at times like these, you may be able to see your child with more detachment. Maybe you see a shape, some colors, a line that echoes a line in the background.

One motivation is not necessarily better than the other. But I think it can be very helpful to be able to detach yourself from your child a little. Look at her as an element in the composition — like an apple in a still life.

Chapter 5

Composition

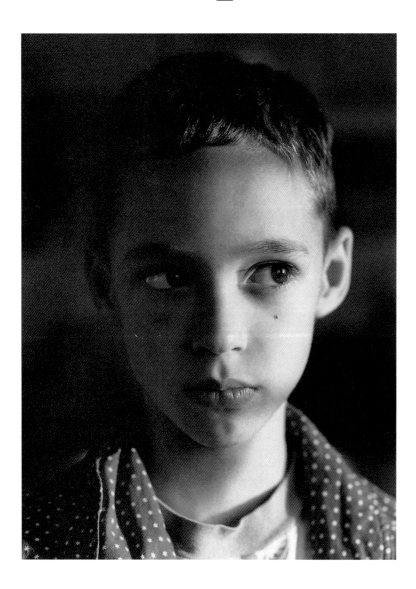

Coming in close and shooting with a wide aperture is a reliable way to get a clean, simple shot.

Most of the time, as a parent taking pictures of your children, you probably just want to record what's going on at a given moment: that glorious sunny afternoon at the pool or the first time your son took a ride on a sled. But sometimes you happen to get a really good photograph. Usually what makes the difference between nice snapshots and good photographs is composition.

Composition is an artistic term — it means the way the various visual elements of a picture are put together. When you look through the viewfinder and decide how to frame the picture, you're composing it. It's hard to write about composition, for several reasons. First, it's completely visual. I could write page after page about perspective and focal points and negative spaces without getting my point across. Second, how you feel about different composition styles is subjective. It comes down to your taste, which may not be the same as mine. And finally, I realize how hard it is to compose your shot when children are your subject. A lot of good advice about placing the horizon line won't do you any good when the children are out of sight before you get the camera level.

I can't tell you how to compose your pictures; I can only give some suggestions for improving your composition overall. This may not be important to you right now, but eventually, if you want to take excellent photographs, you're going to have to think about composition.

Getting Closer

There are a few shortcuts. If you're too busy or distracted to give much thought to composing a shot, I suggest getting as close as you can. The most common mistake beginning photographers make is to stay too far away from their subject. Suppose your child is playing with his toy bear on the living room sofa. It's a wonderful scene; you rush to pick up the camera, and you shoot from across the room. When you look at the action, you concentrate on your child — your mind selects him as the important part of the image. But the camera won't do the same thing. The camera will simply reproduce everything else in the shot: the sofa, the wall, and several feet of carpet. That wasn't what you wanted. You wanted to capture the child playing with his bear. Move in closer or use your zoom lens. Lose the carpet and the arms of the couch. Get the expression on your child's face and the texture of the bear's fur. You'll improve most pictures a lot by moving in. This pointer may seem obvious to you, but it's very important, especially with small children. You need to get down to their level. Your first instinct should be to crouch down so that their eyes are at the same level as the camera. They immediately fill up much more of the frame; you aren't left with a lot of empty space over their head.

Another quick way for most parents to improve their photographs is to turn the camera around. Many people forget about the option of a vertical format and always hold the camera horizontally, but people aren't horizontal, they're vertical. So if you turn the camera, you get less of the background you don't need and more of the person. (If you're shooting with a compact, remember to keep the flash at the top.)

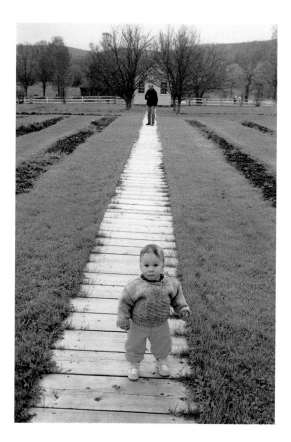

This photo was taken at Hancock Shaker Village, in western Massachusetts, which is laid out on strict geometric lines. The vertical line leading straight to the rear stresses the perspective. Notice how the pathway is centered between the trees and the windows of the house.

Learning to Look

On the other hand, maybe you do want to work on how to compose your shots. Some people teach composition as a series of do's and don'ts, but I've always blanked out when I've tried to approach creating this way. What I suggest is that you look. Look at photos in newspapers, magazines, books — see what you like and what you don't like. Do you prefer simple, clean shots? Or do you like a more complex image, with lots going on? Do you like a dramatic background? Close-ups?

A friend of mine who's an art teacher says one of the most valuable exercises she knows is tracing. She suggests putting a sheet of tracing paper over an image you like and then tracing the basic shapes. As you trace, you notice new things, like direction lines that move your eyes around the picture. You realize how the shapes relate to each other. And you also become more aware of the negative shapes — the spaces between forms. If you try this exercise only once, you'll see what she means. When you aren't distracted by the details, the "bones" of the pictures are more obvious.

You can analyze your own photographs the same way. Look back at the rolls you've shot and pick your favorite images. Why do you like them best? Once you're aware of your preferences, you'll be able to recognize what will make a striking image as it happens. (These are often the moments when you say "I wish I'd brought the camera!") What you're really working on here is training your eye. Every photographer needs to learn how to see not just what he or she knows is there, but what it *looks like.*

I don't want to list a set of rules for composition, but I will point out some considerations that affect a picture's composition. You probably can't control them all; in fact, you may not be able to control any

of them, especially if you've just grabbed your camera in response to something the kids are doing. But gradually you'll be able to integrate your tastes into your vision so that you can intuitively compose a photograph. This is something all photographers try to do and good ones never stop doing.

Elements of Composition

One basic issue is the **position** of your subject. If you think of the picture frame as a series of parallel planes facing you — foreground, middle ground, background — you realize that the children will occupy one of these planes. Their placement affects the composition and the mood of the photograph. If they're in the foreground, you'll get an intimate portrait. You can pull back to take in what they're doing and capture the action. Or if you're far enough away

The low horizon line here gives a feeling of expansiveness to the photograph. The pearly colors of sand and sky, along with the silhouettes, create a strong sense of time and place, even though the faces aren't visible.

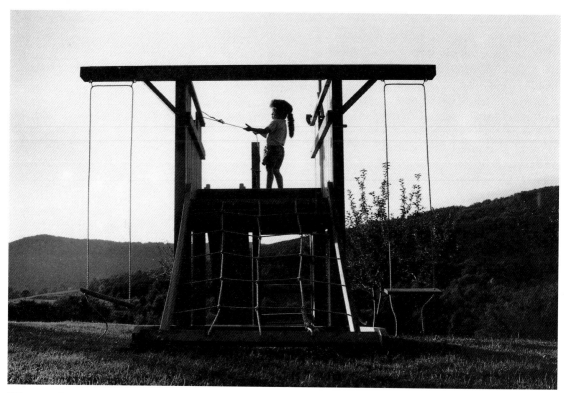

When you have a strong geometric composition like this one, centering your subject makes sense. I crouched down very low to give the climbing frame a monumental feeling.

to get a lot of the background into your shot, you can record the surroundings, too. This, by the way, is the beauty of a zoom lens: you can slide the barrel to the point that will give you precisely what you want in the picture.

Of course, sometimes you don't have a choice. If you're in your living room there isn't going to be a distant background. No matter where you are, however, it's important to pay attention to the **horizon line.** Unless you're deliberately out for unsettling effects, it shouldn't tilt. You might not think this matters indoors, but there's usually some kind of giveaway, like the line where the floor meets the wall.

When you're outside, the position of the horizon influences the mood of the picture. If it's low, you have a lot of sky — the picture feels

open, expansive. If it's high, you get more ground, and the picture feels more intimate. So when you're composing your shot, bear this in mind. Get down low (on your stomach, if you need to) and see if you like the effect. Stand on a rock or a chair to get some extra height. Just a few feet can make a lot of difference.

The next point is a bit more complicated. Think of your subjects as **shapes** for a moment and consider the way they interact. Imagining them as silhouettes might help. Are they all assembled in a static line? Are they all clumped together on one side of the picture frame? The ideal here is to have the eye move from one figure to another. If you're posing your subjects, try staggering them rather than lining them all up at the same distance from you. Think about varying their height, so some are sitting, some

The relationship between the figures makes this picture for me. Your eye flows from the boy lying down to the boy bending to the boy standing up, and they make a triangular shape with the figures of the fathers in the background.

Crowd shots often look
cluttered, but in this case
the boys' bodies create
an irregular pattern.
Notice the contrasts
between the dark,
straight, square lines of
the climbing frame and
the pale, rounded arms
and legs of the children.

kneeling, some standing. You want the viewer's eye to dance around a little from face to face.

While you're looking at the shapes of your subjects, think about **balance** as well. Perfect symmetry, where one side of the frame mirrors the other, makes for a fairly static shot. It's so automatic for photographers to center their subjects that many autofocus cameras place their focusing zone in the center of the viewfinder. But unless symmetry is a dramatic point of your photograph, it can be more effective to frame your subject off center. (If you're using an autofocus camera, be sure to focus on the subject, then reframe the shot with the focus locked.)

I know I said I didn't like rules, but this one can be helpful. It's called the rule of thirds. If you mentally divide your viewfinder into thirds horizontally and thirds vertically, the subject should be located on one of the dividing lines — in other words, a third of the way in from the left margin or a third of the way down from the top, or at the intersection of two lines.

You won't need to do this if you're in very tight, but if you're at a distance from your subject, it can give the picture a dynamic, interesting balance.

It can also be helpful to identify the photograph's **focal point,** with objects leading toward it and away from it. For instance, the line of a mother's arm might guide the eye to a baby's face. Or the surface of a slide brings the eye to the child at the top. This sounds elaborate, but just ask yourself: what is the main point of this picture? That's your focus. And maybe if you move around a bit, you'll find an angle that sets off your point of focus dramatically.

The key to this photograph is the flowing line of the children's heads and the sticks.

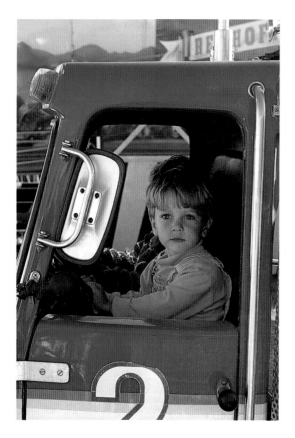

Color can be a major element in your composition. Here the bright blue surrounding Tim's face made his blue eyes blaze.

The **background** also deserves some consideration, whether you're in a national forest or your own backyard. One option is the look of strong geometrics for a background. In the photograph to the right, the sharp shadows and the contrast between the very regular planks of the wall and Tim's figure made the kind of image I respond to. This may not be your kind of shot, but you should always make sure you're aware of what's behind your subjects and, if you can, eliminate anything extraneous (or shoot with a large aperture to blur the background). If you're in a grove of redwoods, pose the family next to the trees and not near the garbage cans! It sounds obvious, but we've all overlooked elements that didn't belong in a picture because we just didn't see them at the time.

Finally, you need to think about **color.** Bright colors, which children tend to wear a lot, stand out. Softer colors, or pastels, allow you to focus more on the children's expressions. A lot of portrait photographers recommend that their subjects wear a pale color for this reason. But of course you don't dress your children every morning for a photo session. I mention color simply because most parents do shoot in color, and it's a powerful part of a composition. Think of the classic film and book *The Red Balloon.* For the most part the other colors are neutral, enabling the clear, bright red of the balloon to jump off the screen and the page.

Try not to let too much bright color overwhelm your subjects. If you can balance the color in a shot the way you balance the shapes, so much the better.

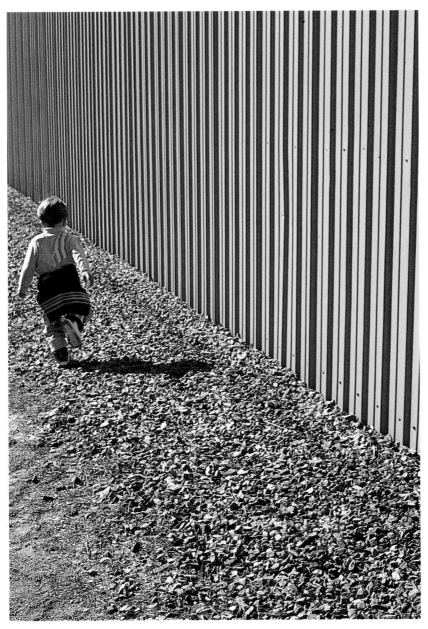

The contrast between the strong vertical of the wall, the diagonal line where it meets the ground, and the irregular shape of the child, placed close to the edge of the frame, gives this photograph a strong, simple composition.

Your Working Method

This is a lot to remember, and I don't want it to sound like a series of rules to follow. As I've said, photographing children is usually a matter of reacting as fast as you can, without much time for thought. But even this kind of photography involves choice and selection. You shoot at this second instead of that one; you aim the camera here instead of there. The points I've outlined above are things to think about while you're selecting.

You're not completely helpless, either. Composition isn't a matter of luck. Photographers tend to fall into two camps, those who arrange their subjects and those who compose through the lens, by moving around. As you might have guessed, I belong to the first group. What I do as a commercial photographer is take a clean space and build a photograph. For instance, I take a wooden table and the ingredients for an apple pie and arrange them to my liking. When I photograph people, I do the same thing. In a beautiful setting I'll try to arrange the people in the frame the way I want them.

Unfortunately, this is hard to do when you're photographing people, especially children. You really can't expect a child to stay in a certain spot for very long without moving around, and even adults tend to get self-conscious if you direct them too much. So you have to set up your basic shot and then wait until the subjects have forgotten about you. If you're at the beach, you might tell the children to go dig a hole in the sand. While they're busy digging, you watch them, holding your camera to your eye, and shoot at the right moment.

Though I find this way of working — actually arranging your subjects in the frame — a lot easier, some people are more comfortable with the second approach — leaving the subject undisturbed while you move yourself and the camera around until you like what you see. If you're going to work this way, you need to train yourself to really *see* what's in the camera frame. It's easy to ignore things like a hand sticking into the frame or an awkward shadow or a diaper pail in the background.

You can also combine methods. Naturally, with a baby who isn't mobile you'll be spending more time crawling around, seeking out his best angle. And if you're on vacation, you're more likely to set up a shot to include some of the background. You have to respond to the circumstances. And for day-to-day shooting, you're the judge of what makes you most comfortable.

You also know what produces the best pictures, or the pictures you like best. Everything I've just said about composition won't be much help unless you look at the pictures you've taken with a critical eye and learn from them. Ask yourself: what was I trying to do in this shot? Did I succeed? Would it have worked better with more background? Less? A higher horizon? More color or less, or in a different place? What if one of the kids had turned his head or had been looking at his buddy? Such critiquing is something you as a photographer should constantly practice, since your ideas and preferences are always growing and changing. Critiquing will help your personal style as a photographer emerge.

In this simple composition the shapes of the two bodies echo each other.

Chapter 6

Baby Pictures

Photographing indoors without much light can be a challenge. The baby was placed as close to the window as possible. I took the shade off a nearby lamp and used ISO 1600 slide film.

All the pregnancy and childbirth manuals spend lots of time telling you what your baby is going to look like. They talk about puffy eyes and scaly skin so that you won't expect to have a plump, grinning baby from day one. Nonetheless, every parent thinks his or her newborn is beautiful. And they are — they're miraculous. However, the first three months of a baby's life aren't his most photogenic.

This should not discourage you. Of course you're going to take lots of pictures of your baby. But for the first few months, simply recording how things were is a more realistic goal than getting stunning photographs.

At the Hospital

Take the hospital, for instance. The mother looks (justifiably!) tired and probably has on one of those ugly hospital gowns. The lighting in hospital rooms is not exactly magical. The baby is very small and looks like she's been through a prizefight. And there are all kinds of unglamorous objects around, like plastic water pitchers and blood pressure cuffs. How can you get a good picture?

Remember, this is reportage. You're not after a beautiful photograph, just a memory. Try to find a window to get natural light, which will make a more interesting photograph. Use flash only if you have to. Since newborns can't really cooperate, the photo session will be swift. Keep it simple and get close. Don't stand back at the end of the bed to get a better view of the hospital furniture. The baby asleep in her crib can make a nice shot. Many postpartum mothers wouldn't mind being left out of these first photo sessions. In fact, if the mother is the one who normally uses the camera, she probably won't remember to take pictures at the hospital, because her mind is likely to be on other things.

There are only so many ways to pose an infant who can't yet control his own body.

Life with Baby

Once you get home with the baby, a couple of things make it possible to take better pictures. The most important one is the ready availability of natural light. I love the gentle aspect of natural light for photographing newborns and infants. Their eyes are so sensitive for the first weeks that it seems kinder not to have flash going off in their face more often than necessary. If you've ever seen a baby grimace after a flash photograph you'll know what I mean. So I'd suggest that you load your camera with fast film (ISO 400 to 1000) and stay close to the windows when you shoot. If you're using a manual camera you can slow down the shutter speed to 1/60, since infants don't move

This memorable shot of a floppy baby supported by a pumpkin is a perfect example of creative posing.

very fast, and use a wide aperture. Just remember to focus very carefully if you do this, because you won't have much depth of field.

The hardest aspect of photographing an infant is posing her. Little babies are floppy; they don't have much muscle control, and thus they have to be supported all the time. Sometimes it's hard to think of a way to pose the baby other than lying flat on a bed or the floor. When my mother was visiting I got some terrific pictures of Ben lying faceup on her lap. His head was at her knees, and I stood behind her, shooting over her shoulder. This can be wonderful when the baby is starting to focus on faces and voices and beginning to identify people.

Here are two birth announcements that focus on the tender relationship between mother and child. The fact that they're shot in black-and-white gives them a timeless, romantic feeling.

Parents tend to take lots of pictures of their infants, which makes sense, because babies grow and change so fast. I have friends who made a little ritual out of this, and the photographs make a really great series. Once a month they propped up their daughter in a corner of their couch to take her picture. They tried to do it around the same time of day on each occasion, so the light would be the same. They have a dozen photographs from the first year that show all those landmarks of growth and development: the hair growing, the teeth coming in, the baby grinning at the parent behind the camera. It's a precious record of that first year, and posing Edith in the same spot emphasized dramatically the way she grew. You might even want to include a stuffed animal or some other prop in each shot, to underline the baby's incredible growth.

Lots of people like to send a photograph of the baby along with a birth announcement. Some of my favorites have been a little unconventional, like one that showed a baby on a bed next to a football — they were exactly the same size. Another friend sent an announcement that was a picture of just the baby's foot next to his mother's hand. Both pictures stressed the remarkable thing about newborns, which is how small they are. And, again, since a baby's first three months aren't his best time to sit for a portrait, sometimes photographing only a part of him results in a better-looking photograph.

The more traditional approach to the birth announcement photo is the parents holding the baby. There are a few points here that can improve the photo session. First, use natural light if you possibly can. Time your session to make the most of sunlight coming in your window, or take the baby outside if the weather permits. Second, keep the proceedings short. Even the calmest baby in the world won't stay calm for long in those first weeks. Third, stay flexible. The best time for a session like this is probably after the baby has eaten, in that brief wakeful period before the next nap. Make sure she is comfortable: held close, or lying on a stable, flat surface, or wrapped in a blanket, whatever makes her happiest. And don't worry if the baby is asleep. What's really going to make this picture is the parents' expression as they look at their new baby. This brings me to my last point: get someone else to take the shot if you can. Most current cameras include a self-timer, but if you don't use it often you're going to be jumpy, and it will show.

Photographing older siblings with new babies can be complicated. Some siblings react to new babies by ignoring them completely. If the older child doesn't mind, the easiest way to take this shot is to place the baby in his lap after you've made him sit cross-legged on a bed or on the floor; if the baby slithers away from him, no damage will be done. When you see these pictures they may look a bit stiff and artificial, but the kids look that way in real life, too. Not many small children feel at ease holding a newborn.

Older Babies

You take a lot of pictures of your infant because she's so amazing. Then as she grows and gets plumper, starts to smile and react to you, you take a lot of pictures because she's just so *cute.* I think there's no way you can shoot too much film at this time. Babies change so fast that you want to hold on to each phase as long as you can. We can't do that completely, but photographs are powerful reminders.

, The best insurance for great pictures of babyhood is total preparation. Make sure your camera is always loaded and ready to go. It's hard to know what kind of film to choose when you can't predict the shooting circumstances. If

This is an example of why you should always be ready with film. Ben was sitting in a shaft of light, and when he pulled the plastic bowl onto his lap, it glowed. I ran for my camera, in this case a compact, and got the shot.

The photographs on these two pages are among my favorite images of Ben as a baby. The light, the mood, and the composition are typical of my photographic style. Though they're very personal, they also feel like pictures of every child.

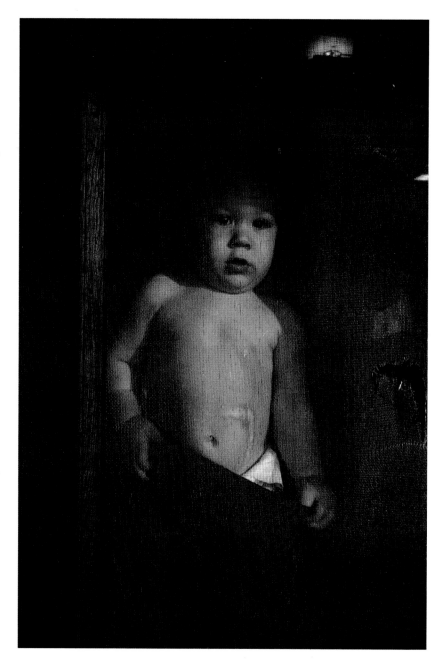

you think you'll be taking most of your shots indoors with an SLR, use a fast print film so that you can avoid flash. Though this could rule out shooting at night, small babies aren't at their best after around 6 P.M. anyway, I've noticed. On the other hand, if you use an automatic camera, turning off the flash may not be possible. In that case, a slower film like ISO 100 or 200 will give you better results. I also like to shoot black-and-white from time to time. With babies, texture is important, and black-and-white film does a great job of rendering fuzzy hair and silky skin.

If your camera is always ready to go, you can shoot a few frames here and there. Babies rarely do anything for very long, so this isn't the same thing as shooting two rolls of an older child's birthday party. When you get the prints back you'll have three pictures of the baby chewing on a block, four of her investigating her toes, and so on. I know some extremely organized parents who keep shooting logs, recording dates and information for each frame on a roll. They'll always know that they took that shot of Max in the laundry basket when he was four months and three days old, which is impressive.

What you're trying to do with these first photographs is build a picture of who this little person is. Think of it as a cumulative portrait. As the baby's character emerges, you'll capture facets of it on film. Don't try to keep everything all sweetness and smiles; many babies seem pretty miserable during their first few months. Some of them look resigned, and some of them fight the whole unwelcome experience of getting used to the world. Those expressions should be captured, along with a child's dawning enjoyment of life.

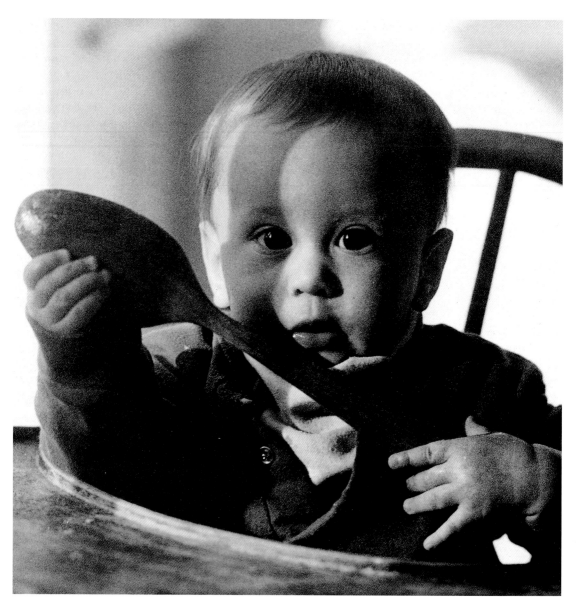

Taking lots of pictures builds a portrait of your child. A close-up like this one of Ella in the high chair can focus on physical details like her fine hair and the shape of her hands.

Of course there are landmarks in the life of a baby that are great to have on film. The problem is that babies can't cooperate, so it may take a lot of tries to snap that first smile. Face it: you won't *get* the first smile on camera. But don't worry; just wait a few days until the smiling reflex is well entrenched. Some babies grin at the drop of a hat, and some make you work hard. Does music do it? Rattling a toy? The sight of your face? Once you locate the trigger, you can be prepared. Get the baby posed and the camera focused, then coax the little guy to smile.

By the time a baby is doing interesting things, he can also attempt exasperating motions like grabbing the camera every time you point it at him. This is why it's helpful to have an accomplice, especially if you're trying to capture a certain behavior. For instance, a newly walking baby will happily stagger toward a parent with a camera. But unless you have one of the advanced automatic models that sense

the speed of a moving subject and adjust the focus accordingly (this is called predictive focus), you're going to have trouble focusing on a baby walking toward you. Much better to have the baby walk toward someone else, its profile toward you. Your focus will be better, and you won't have to lower the camera if the baby falls down. Most babies love water, so bath pictures are a natural, but I was always nervous taking bath pictures alone. What if Ben slipped? I'd try to get Fred to stand by and spot Ben in case he fell over.

The most commonplace elements of life with a baby are worth photographing.

Another fleeting stage: this baby is thrilled with walking but not quite sure she wants to do it all alone.

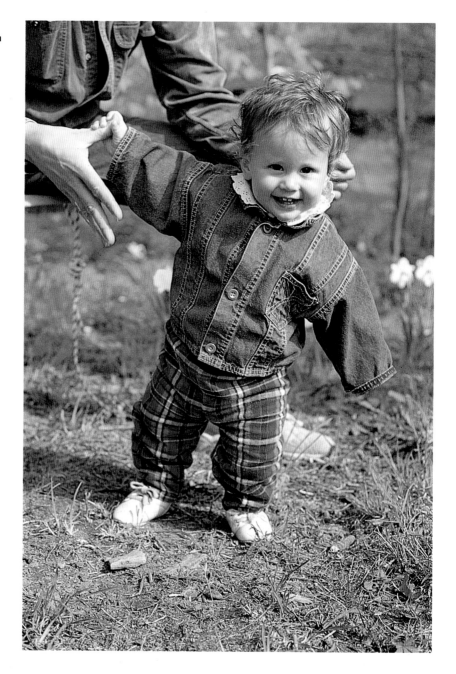

A baby's life is full of little rituals and events that can make wonderful pictures. By six months many babies have adopted a snuggly toy or blanket as a source of security, and you'll certainly want to photograph your baby with her snuggly — the problem may be capturing her without it. You might want to do a photo story of a day in her life: waking up, having breakfast, going for a walk, and so on. Babies aren't the world's neatest eaters, but that's part of the whole experience for them and for you. A child's expression as she tastes something new can be charming. Take pictures of your child sleeping. One of my favorite pictures of Ben is a shot of him asleep in his car seat, clutching a stuffed rabbit. A sound sleeper won't be wakened by the flash if you want to take a picture at night.

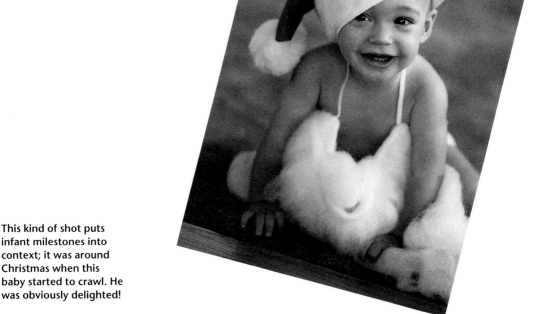

This kind of shot puts infant milestones into context; it was around Christmas when this baby started to crawl. He was obviously delighted!

Eating is a big part of a baby's life, but not necessarily a neat one. Gusto is more the point of the enterprise.

I was having trouble getting a natural look in this shot until I asked Stephanie to look over her mother's shoulder at the baby. Sometimes a simple change of position can pull a photograph together.

Until your child acquires mobility, you will have to do the moving around. Once your baby is starting to lift her head, you might want to put her on your bed and squat down to her eye level so you can catch her with her head up. Lie down on the floor and shoot a little upward to get a fresh view of a baby in an infant seat. Since most of the time it's unsafe to bring a small child up to your eye level, be willing to get down to his or hers.

Religious Ceremonies

Many cultures have a ceremony welcoming new babies into the community, like a baptism or a naming ceremony, that often takes place soon after the baby's birth. The infant may not be thrilled by all the attention, so don't feel you have to strain for elegant pictures. The main purpose is to record what happened. You'll want to get shots of the officiants and participants, and if they look a little stiff and formal, there's not much you can do about it. Because most churches and synagogues don't permit the use of flash during a service, you should plan a quick photo session, preferably beforehand, because afterward the baby will probably need some peace and quiet. If the service involves the baby wearing something special like a christening robe, put it on at the last minute to keep it looking fresh. And if the baby howls throughout, remember, that's part of life, and you'll be able to laugh at it later.

Party Shots

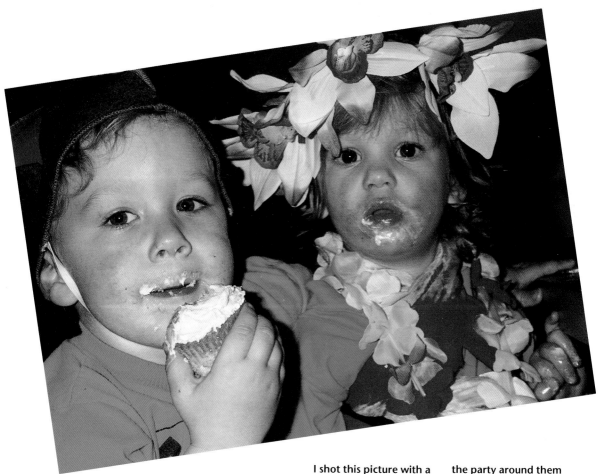

I shot this picture with a compact camera, using the 70mm lens. By getting close to Ben and Lila, I could eliminate the distracting elements in the party around them yet still catch Lila's orchid headdress and the icing on her knuckles.

If you get your camera out of a drawer only once a year, it's going to be for your child's birthday party. Both you and your child, later on, will appreciate good pictures of this event.

Because it *is* an event. And if you ask around, you'll discover that it's an event lots of parents find incredibly intimidating. Most of the parents I know get much more anxious about their children's parties than about their own. Children care a lot about their birthday parties, and you feel it's up to you to make them go smoothly. Taking better photographs may not seem important compared with weeding the guest list down to a manageable size, finding the right kind of favors for the goody bag, or making sure you have enough games planned to fill up two hours. But when the party's over, what you'll have left is the pictures, which is why you need to plan ahead.

I have a lot of suggestions for this occasion, some of which may feel forced to you. Don't feel obliged to turn the party into a photo shoot just so you can get good snapshots! You'll see, however, that most of these ideas don't take much time, and they can prevent you from taking panicky, poorly exposed shots because you left them to the last minute. Believe me, I'm an advocate of going with the flow as much as anyone — I just like to lay the groundwork first.

If you can, set up games like pin the tail on the donkey in well-lit spots so you won't have to use flash.

Simplify and Delegate

On occasions like children's parties I'm grateful for automation in cameras. If you have access to a highly automated camera, use it for the party. This is when technology really comes in handy; it's great not to have to worry about exposure, flash, or focus. (Though I prefer not to use flash in general, it is a help at a party, because unless you're outdoors, the light will probably be insufficient.) Using an automatic camera also means that someone else can take over for you, which can be a lifesaver. I know this is a book about how *you* can take better pictures of your children. But I learned a lesson at Ben's first birthday party. I was totally frantic and completely forgot about the photographs I wanted to take. There would have been no record of that party if a friend hadn't quietly picked up the camera.

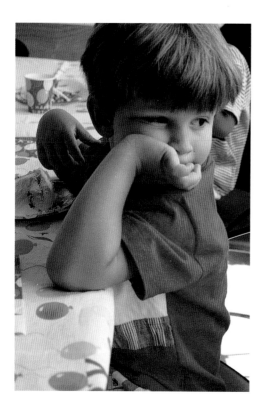

Every party has its quiet moments; these can be good times to snap individual portraits.

You can't take care of everything. You may need to help the children decipher the clues of the treasure hunt or keep overexcited toddlers from hitting each other. Juice will spill and balloons will pop. Meanwhile something hilarious may be happening across the room, and you won't be there with the camera. But if you've appointed someone else photographer, maybe he or she will be. If you're going to have a friend take over, be sure he or she knows about any specific shots you want to get.

Another strategy is to ask other adults at the party to bring their cameras. Have film ready for them and ask them to leave the finished rolls for you to process. It's fascinating to see several different people's versions of the same event, especially since it will probably be a complete blur for you.

Scope It Out

No party takes place without a lot of preparation. You'll need to check out the place where you're going to have the party with an eye to taking pictures there. A friend of mine took her daughter and some of her friends skating on a local pond a few years ago. They had a table set up to serve hot chocolate, and naturally she stood there to take pictures. Unfortunately, the view across the pond was of a battered old shed with two derelict cars outside. Those cars were in the background of almost all the pictures.

You aren't always going to have something this dramatic to avoid. But even if you're having the party in your living room, try to see it with eyes like the lens of a camera. Make a mental note of the angles you'd like to avoid: the long shot down the hall to the (inevitably open) bathroom door. The spot on the wall where the poster paints didn't quite wash out. The radiator, the electrical outlets, the kitty litter box.

While you can try to shoot your party in natural light, I would recommend using a camera that has flash, so you have that option. Most indoor situations won't be flooded with light from outside. Even if you do have strong directional light, it presents problems of its own, like having to avoid backlight. Parents shouldn't have to worry about backlight in the middle of their child's birthday party!

What to Look For

My next idea may seem like advice from a control freak, but you don't have to be too exact about it. I believe that everyone should think *ahead of time* about just what pictures they want to take at the party. It's too easy to forget about the camera when the party boy is whacking at a piñata, and once that candy's all over the floor your shot is gone for good. I'm not talking about a formal shooting script, but here are some features of the party you might want to capture:

Kids Arriving

Your subjects will be fresher, more cooperative, and tidier when they first arrive, so take individual pictures of them then rather than later. Sending a photo of the child to her parents is a friendly gesture. If you have access to a Polaroid you can go a step further. Buy little picture frames ahead of time, one for each child. Personalize them with markers and decorate them, if you're talented that way, or have the kids decorate them as a party activity. Take a Polaroid of each child and tuck it into the frame when it's developed. The pictures in their frames function as place cards at the table and as party favors. This works best with preschoolers, the group that's old enough to enjoy admiring themselves but not too old to wish for something they've seen advertised on TV.

If the entertainment includes hats, costumes, or props, be sure to shoot them as well.

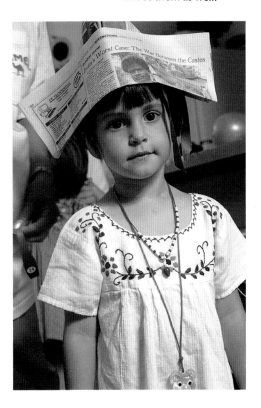

85

During the Action

You'll want some group pictures, and this is one of the best times to get them. If you've planned any quiet, craftsy activities that will keep the children still for a few minutes, you (or the designated photographer) can prowl around watching for the good shots: children helping each other, a tongue stuck out in concentration, or even the entire group. If you have a magician or someone who does tricks with balloons, try to get a shot of the whole crowd, absorbed. It won't be easy. If the kids are sitting in a circle, you're going to miss some of them and get the back of some heads. If they're in rows in front of the performer, chances are you aren't going to be very welcome popping up behind him or her and letting off your flash. It's worth discussing this quickly with the performer ahead of time to see if he or she has suggestions.

The children may be sitting down for some of the party, but they are bound to spend most of their time on the move. If you want to shoot while they're playing ring-around-the-rosy or impersonating dinosaurs or having three-legged races, stay in one place. Keep the camera to your eye and let them move around you.

Candles, Cake, and Presents

The blowing-out-the-candle shot is a must, of course. Kids love these pictures of themselves with their cheeks puffed out and their eyes shut. I also like to concentrate on the moments just before the candle is blown out, when everyone, especially the birthday child, is watching that cake make its way to the table. The children are usually very intently focused on the candles, and it can make a nice shot. Be careful about the lighting at this point; the candles don't cast enough light to change things radically, but dimming the room's lights to make the candles show up will usually make flash necessary. It's an obvious point, but that's the kind of thing it's easy to forget in the middle of a party.

Kids are little, so it's important to get down to their level. Don't be afraid of unconventional angles: the uneven bowl of apples and the girl's hand stretching out of the frame supply a great sense of motion.

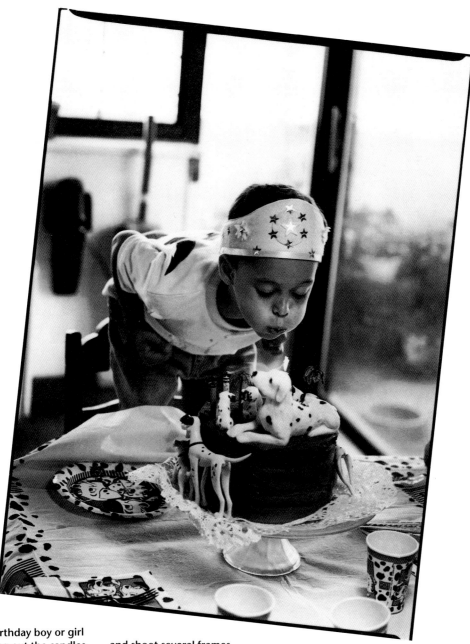

The birthday boy or girl blowing out the candles is the one shot you don't want to miss. Get as close as you can, prefocus on your subject, and shoot several frames as fast as you can. Make sure you aren't on frame thirty-five of the roll before you start!

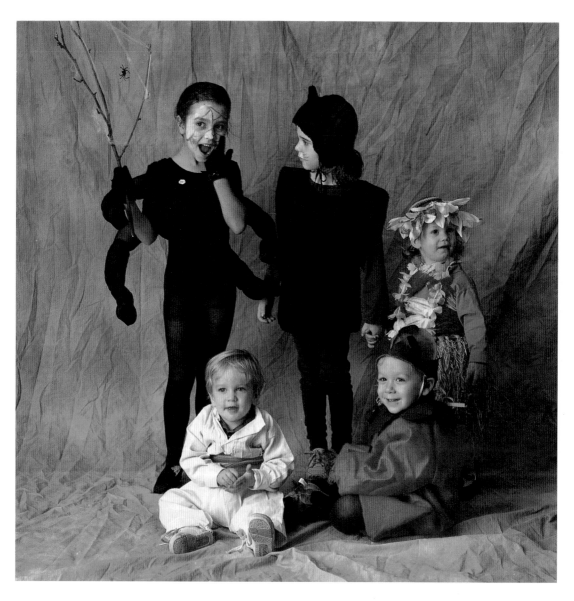

In a successful group shot the children don't all have to be looking at the camera. Interaction among them can add spice to the picture.

I always think I'm going to get good pictures of Ben when he's opening presents, but it's not easy. For one thing, the other kids tend to crowd around, so it's difficult to get a clear shot at your child's face. The wrapping paper also adds a distracting element. The best way to manage this shot is to position yourself between kids, in the front row, and get down to the birthday child's eye level. Don't try to shoot this from above; the shot will be cluttered, and you won't really catch your child's excitement. I tend to fall back on a basic rule of thumb: get in as tight as you can without disrupting the fun.

Of course, not all parties are birthday parties. A lot of the illustrations for this chapter were shot at a Halloween party. The same techniques work for any party. But for a Halloween event, I urge you to make portraits part of the action. Set aside a corner to use as a photo booth and drape it with an old white sheet or some other neutral backdrop. The children will enjoy taking turns being photographed in their costumes.

Stocking Up

This is another obvious point, but I'll tell you anyway. Don't run out of film. Buy more than you think you'll need. If you mentally prepare a shooting script, you'll have a sense of how many shots you'll be taking at various stages of the party. Allow some extra for those unexpected, irresistible moments. And the older your child is, or the more that's going on at a party, the more film you'll need. You can probably shoot a group of four two-year-olds easily in a roll of thirty-six or even twenty-four frames, but you'll need a couple of rolls for older kids. I recommend shooting print film for a party, because negatives are so much more forgiving than slides — if your exposures aren't exactly correct it won't matter so much. Make sure that you have an extra battery on hand, too. This is also a good time to clean off any fingerprints or smears on your lens.

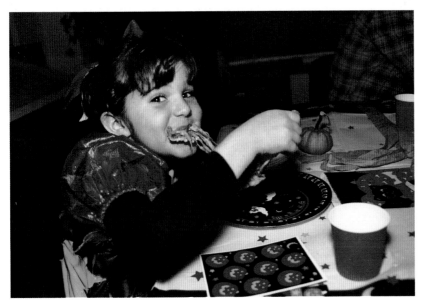

At first glance this might look like an awkward photograph of a girl with a mouthful of pizza, but her direct, merry gaze at the camera shows us how much she's enjoying herself. You can hardly help smiling back at her.

Chapter 8
Milestones

This is an informal snapshot of three generations of Phelpses. The simple composition, their open expressions, and the strong family resemblances are what make it special.

One of the hardest things about taking pictures of children is that so often we don't have much control of the physical circumstances: the light, our vantage point, our distance from the subject. This is especially true of occasions that we want to mark and remember, like graduations, performances, or holidays. In a number of situations we encounter as parents, there just isn't going to be a way to get a great photograph.

That doesn't mean we shouldn't take pictures at these events; it just means that the approach is a little different. Sometimes I think of it as reportage and imagine that I'm a photojournalist trying to record what's happening as clearly as possible. That takes some of the frustration out of times when my subject is part of a big group or when I can't get close enough to make a clean composition.

I've grouped several of these situations together in this chapter to discuss some ways to improve your chances of getting good pictures. But for all of these milestones, your expectations should be different than for carefully composed shots. You're creating mementos, not art.

Family Pictures

Cameras are usually part of the paraphernalia when families gather. In an era when many of us live far from our parents, getting children together with their grandparents is a big event. But what often happens is that everybody lines up on the couch for a couple of stiff group shots, and then the camera is forgotten until the roll of film gets developed months later and a batch of not very interesting group pictures comes back. You send one to your mother-in-law, and the rest get put in the drawer. Or precisely because you want to avoid these stiff pictures, you wait for something photogenic to happen. Then you end up coming home with no pictures of your extended family because you never picked up the camera.

There are better ways to handle this. First, here are some suggestions of things to shoot that you might be ignoring. If you go to visit someone else, the surroundings are different, and your children will respond to them. Maybe there's a pet, or fun stairs, or a great climbing tree. You can easily grab some candid shots of your children interacting with these things. The routine will vary a bit from that of your own household — the table gets set in a new way, or maybe your sister's children read out loud to each other before they go to bed. Just keep the camera handy and click away. (A compact camera with flash and autofocus is probably the best choice for this kind of candid photography.) Try to keep the frame as uncluttered as possible and really *look* at what you're seeing. This can be very important in new surroundings, where you may not register unsightly backgrounds.

I'm not suggesting that you never take posed shots of your family. I know some big families that do group photos every time they get

When you're photographing a big group, don't be afraid to try something silly like this cancan lineup. It got rid of the self-consciousness that can make family-gathering shots stiff.

together, about once a year, and it's wonderful to look at these pictures in a series. Some of them are in the mountains, some at the beach, some in the parents' home. Several were taken at weddings, and the group keeps growing as they add spouses and children.

If you can get a few of the group at a time to gather for fifteen minutes or so, you can set up small, informal photo sessions. Put your children and their relatives together in some attractive space with good light. I usually go outside if possible; maybe drag out a chair or two so some family members can sit down comfortably. Settle them down in a loose group, preferably not in a straight line but staggered a bit. Put the smaller children in the adults' laps, to help create interaction between the subjects. (If

they'll stand for it, place the children with adults other than their parents, to make it more interesting.) It might help if they have something to do, like shucking corn or listening to music — anything to take their attention off you. Then shoot a roll, keeping the camera up to your eye as you wait for interesting interactions.

Color film is the most popular choice for family photos, but black-and-white can be especially effective. It forges a link with most of the family photos from our childhoods. Seeing your children in black-and-white photographs with your parents, the way you may have posed as a child with your grandparents, can have a strong emotional impact.

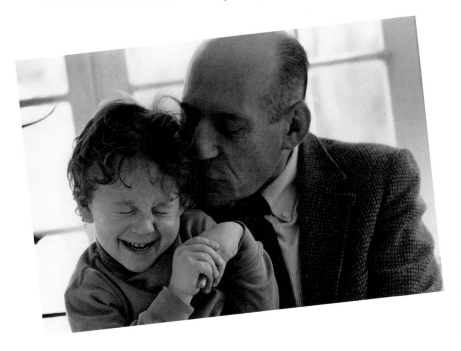

My stepfather was out on his sun porch, sitting for a formal photograph he needed to have taken, but he was feeling self-conscious. Ben wandered in and climbed up on his lap, and he softened immediately; we got a great series of shots, and he used one with Ben instead of the formal portrait we had planned. I exposed for the skin tones and let the background go light.

Holidays

Taking pictures with relatives can be a little bit awkward, but for real artificiality, nothing beats the holidays. And there's really no way to avoid that staged feeling.

Halloween

Your biggest problem here is darkness. Although small children may go out trick-or-treating while it's light, the essence of the holiday is being out after dark, dressed up funny. But the flash on most compact cameras is only strong enough to illuminate a distance of about 10 feet. You may have to get that far away to get the full effect of the costumes when you're shooting a group of kids. (A 35mm lens,

which is standard on most compacts, is a big help as far as that goes.) I wouldn't bother bringing the camera along when the children are actually trick-or-treating unless you have a very powerful flash unit.

A daylight dress rehearsal, though not completely authentic, is the best way to manage Halloween. Most children will be happy to oblige, and you'll get better shots. If you're making a costume at home, photograph that process, too. A series showing how a great costume is put together can be a lot of fun.

Thanksgiving

If your children are old enough to help with the preparations, take a few pictures. It will make them feel that their contribution is important, that their participation in a holiday that's often more enjoyable for grown-ups is appreciated. (After all, how many children really enjoy sitting around a table dressed up in their best clothes, talking?)

If you want to shoot the group around the table, remember that your flash power varies. You can't just stand at one end of the table and photograph people where they're sitting, because the closest ones will be bleached out and those farthest away may be in shadow. You have to clump everyone together at approximately the same distance from you. It won't look natural, but it's more flattering.

If you're shooting costumed trick or treaters with flash, be sure to get close to them. Most flash units have a very limited range.

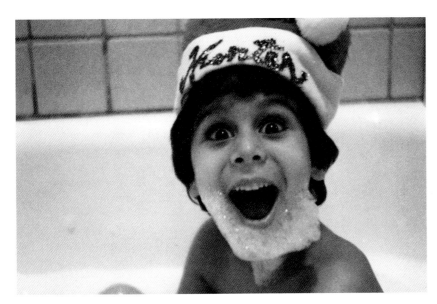

Children start to get excited about Christmas long before December 25, and that anticipation is an important part of the season.

Another strategy is to move around the table, photographing two or three people at a time. If you place them in the same area of the frame each time, you could even line up the finished prints side by side in an album to get a complete picture of the group.

Hanukkah

Like Halloween, Hanukkah is basically a nighttime holiday, which means you'll have to use flash. If you want to photograph your children with the menorah, and the menorah is set by a window, be aware that you may get a harsh reflection from uncurtained glass. Try to keep it out of your viewfinder. There are many different ways to celebrate Hanukkah, but the other constant besides the menorah is the gifts. As I mention in chapter 7 ("Party Shots"), wrappings tend to clutter up a photo's frame; wait until the child is absorbed in a new toy to get a cleaner shot. If you include dreidel games in your celebration, try a few shots with the camera level on the table. This might be an interesting time to play with focus and depth of field, shooting the children's faces beyond the dreidel.

Christmas

Having children really puts the magic back into Christmas. As they start to get excited, so do you, and you may feel like re-creating some of your family traditions or inventing your own. Photograph them. If you bake cookies to give to teachers, snap a few shots. (Try a few pictures with the lens at the level of the table for a different view.) Choosing a tree can be a momentous event for a preschooler. If your children are involved in holiday crafts, taking pictures of them adds extra pride in what they're doing. Since these are candid shots, using a compact camera will give you the kind of flexibility you need. For suggestions on taking a family portrait to use for holiday cards, see chapter 11 ("Portraits").

Although I did shoot Maggie actually receiving her diploma, this shot after the ceremony was more effective. I put Maggie and my father under the trees to soften the midday sun and used a wide aperture to blur the cluttered background.

One of the standard shots of the season, of course, is your child with Santa Claus. Many toddlers are afraid of Santa — their parents usually find this out after waiting in line at a department store for hours — and won't go near him without tears. And maybe the whole idea of having a picture taken on Santa's lap seems corny to you. But a friend of mine has a series of Santa pictures that were taken at Sears over the last twenty years. The photos are taped together and brought out every Christmas. It's fascinating and touching to see them. Sometimes a little sentiment is wonderful.

The next idea is to take pictures throughout Christmas Day. This may sound like too much trouble if you're busy with very small children,

but they aren't that interested in Christmas anyway. When they're a little older, it can be fun to shoot the children opening their stockings, having a special Christmas breakfast, playing with their presents, dressed up for Christmas dinner, whatever your family traditions are — all as unobtrusively as possible. You can sometimes get interesting effects with the lights from the tree if other light sources (such as flash) aren't too powerful. But unless you're really set on using natural light, I'd load a compact with ISO 200, put the flash on automatic, and not worry too much about illumination. You've got better things to do on December 25.

For this shot I was kneeling in front, low enough to be out of the way of the audience. Because I was below the eyes of the performers, the flash didn't produce red-eye.

Performances and Transitions

It's graduation day. Your ticket puts you back in the fiftieth row. The lady in front of you has on a huge hat. How are you going to get that shot of your son accepting his diploma?

For some people, holding a camera is like slipping on a magic ring that makes them invisible. They feel that nobody can see them as long as they're clutching that Nikon. Other people feel conspicuous when they're taking pictures. They think all eyes are on them. These are the people who are reluctant to leave their seat and storm the podium.

I tend to be hesitant in that way, but I hope to get over it by the time Ben graduates from something more advanced than kindergarten — because even a huge telephoto lens can't solve the access problem at events like graduations or recitals or school plays. You just have to pretend you're a paparazzo and get as close as you can without blocking other people's sightlines. At most events like this there is a spot, near the stage or the podium, where people with cameras cluster. Sometimes you have to summon your nerve to join that group, get as close as you can for a few minutes, then relax and be a parent again.

Of course, a good telephoto lens can be a big help. In fact, a zoom lens would be ideal for any kind of outdoor ceremony or event, where you would presumably have plenty of light. You can rent zoom lenses from well-equipped camera stores. Just remember that a long lens intensifies camera shake. To avoid this, use a tripod (which you could also rent) or stick to a shutter speed that's roughly equivalent to the focal length of the lens. In other words, if you are using a 105mm lens, shoot at 1/100 second or faster.

Indoors you have more of a problem, because flash is rarely going to be strong enough to illuminate a faraway subject. Flash on a compact will certainly be inadequate, and it would take quite a powerful flash unit on an SLR to cover the distance from audience to stage. Events such as debates or recitals can be lit in a fairly restrained way, which adds to the photographer's problem. For elaborate stage shows with lots of lights, you can expect the stage lights to supply sufficient illumination, though you must get close to avoid yards of dark audience in the way. (Be sure to meter for the stage, too, rather than the audience.) You should use fast tungsten-balanced film, or expect daylight-balanced film to be a little orange. This is actually a good occasion to use fast black-and-white film; when you think about it, most theater and dance photos are taken in black-and-white. In fact, if you don't know what lighting conditions you'll be facing, it's safer to use black-and-white. Some indoor spaces like gyms or auditoriums may be lit with fluorescent light, which gives a greenish cast to people's skin.

Nothing can replace the actual moment of graduation or an actual performance. But sometimes it pays to shoot at a rehearsal, when things aren't as formal. The dress rehearsal for a play can also be an opportunity to shoot the actors backstage in their costumes. You can get closer for better detail. Backstage action is always interesting, and kids who are about to go onstage and perform for an audience might not mind performing a little extra for a photographer. (You can make yourself very popular with their parents, too, by sharing prints.)

Other events that usually call for photographs include religious ceremonies like christenings, bar or bas mitzvahs, and confirmations. It's rarely possible or even desirable to take pictures during such ceremonies, because flash can be so disruptive. Sometimes the best way to handle the pictures is to line up the participants and take a few shots before or after. At least you'll have a record of who was there and what they looked like on that day. There are times when that's exactly what a photograph is for.

Since all of the children are the same distance from me, they're all lit evenly by the flash, and their simple costumes give the composition a unity that's often hard to get in group shots. Their expressions are priceless; they're all cracking up at a joke in a speech given before their performance.

On the Road

Often when you're traveling you'll want to pull back to get some of the background into your shot — especially if it's a spectacular day.

Everyone takes a camera on vacation. Naturally parents do, too, but they have different priorities. Whether you used to take a point-and-shoot or a camera bag full of lenses and accessories with you before you became a parent, photographing your children on vacation will be a completely different proposition.

I have a friend who says that since she's had children, she doesn't take "vacations." She takes "family trips." The expectations have changed, and your picture-taking expectations will change, too. Getting good pictures of your children becomes more important than getting great architectural or landscape shots. But you shouldn't lose sight of being in a different place. And you also need to remember that you are on vacation — or at least on a family trip.

What to Take

Packing is always an issue when you have children. The amount of stuff you have to take with you does decrease as they get older, but nobody can call it traveling light. Unless you're a really determined photographer, chances are you'll want to take a compact camera on a trip. If you don't own one, it's probably worth trying to borrow one from a friend.

The lighter weight and convenience of a compact aren't the only reasons to choose one over an SLR. Generally you're going to want maximum depth of field for most of your travel pictures. After all, this is one time when the background really matters. So you won't need the flexibility you might have with an SLR. Most compacts also come with a 35mm lens, which is a moderate wide-angle. Again, this can be an advantage when you want to get more into the frame.

You should bring more film than you think you'll need, and buy it from your usual source at home and carry it, rather than buy it wherever you are. Even if you'll be traveling in a relatively sophisticated part of the United States, film might be more expensive there, and you won't know how it's been stored. For all-purpose shots, ISO 200 print film is probably best, though a roll or two of black-and-white can add some interesting variety to your pictures.

It is best to have film developed soon after it's shot. One way to manage this when you're traveling is to bring along mailer bags from a photo lab and send each roll in as you finish it. You'll lighten your load, and there will be pictures waiting for you when you get home. If you're abroad, be sure to treat your exposed film carefully. Roll the leader all the way inside the cartridge so you won't confuse it with new film, and put it in a lead bag for the trip home.

If you're doing a lot of driving in warm weather, you need to be careful about the effect of heat on film. For instance, don't leave a loaded camera in a closed car for hours. If you're bringing a cooler, make room in it for your film (in a plastic bag, of course). And never leave film in the glove compartment.

Another approach to shooting landmarks besides trying to capture the entire object is to emphasize the scale by placing your child right next to the monument and showing her reaction to it.

What to Shoot

I won't tell you what to take pictures of on your trip. But I do have some suggestions that might not have occurred to you. Basically there are three elements to consider in travel pictures: aesthetics, memory value, and kid appeal.

You don't have to give up trying to take attractive pictures of your travels just because there are children with you. There's nothing wrong with shooting scenery that doesn't have your children in it. In fact, it can be refreshing to get away for an hour or so with the camera just to shoot scenes that you find intriguing.

Memento shots don't have to be obvious either. We've all seen too many pictures of people standing stiffly in front of the Eiffel Tower or Buckingham Palace. Of course you want some shots of your children visiting landmarks. But they don't have to be lifeless.

First, don't try to get the whole landmark into the picture. Lots of people buy postcards when they're traveling, even if they are also taking pictures, and I think this is a great idea. Postcard photographers can shoot from the air or use very wide-angle lenses to get the best possible view of, say, the Grand Canyon. That's not your job as a photographer. What you want is your children at the Grand Canyon, or your children reacting to the Grand Canyon. These are entirely different goals.

The combination of the sleeping baby and the mist on the Grand Canyon in the background helps capture a very peaceful moment.

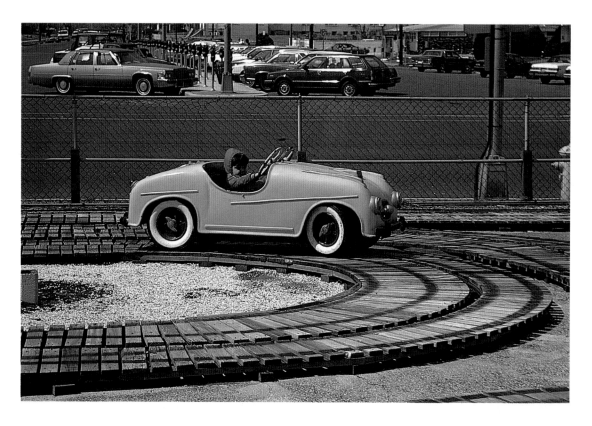

What appealed to me in this scene was the contrast between the bumper car and the grown-up cars in the background. For travel shots you'll want to use a small aperture, as I did here, to ensure that the background details are clear.

You need to be farther away from your subject than you might usually stand; you do need some background. The object here is not to position your kids in a static row in the foreground. As long as you're directing them, do it with a little imagination. It helps if they can sit, for instance. Maybe arrange them in an uneven row, or put somebody a little farther away from the others. (You will be shooting with a lot of depth of field, so they'll all be in focus.) Or give them something to do. Most kids will be happy to stop for a snack or a drink anytime, whether it's on top of Mount Washington or at the foot of the Leaning Tower of Pisa.

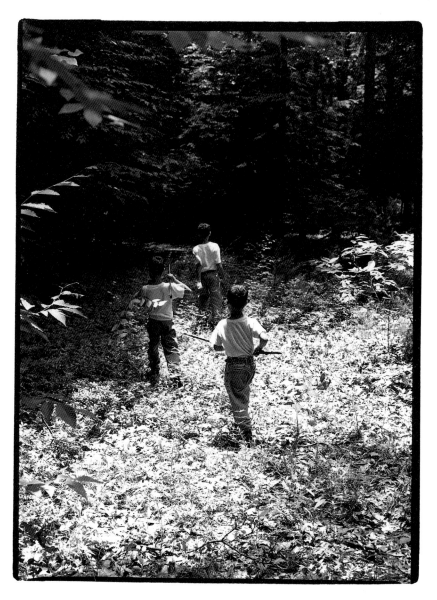

For older children, exploring new places is part of traveling. This photograph catches the feeling of adventure as three boys head off with their sticks into the forest.

Don't center them in the frame — remember the rule of thirds (see chapter 5, "Composition"). And don't feel that you always have to shoot your child's face full on. Sometimes a profile or even a child's back can be very effective.

Most of us with school-age children will be traveling during school vacations. Aside from the lighting problems this presents (which I discuss later in the chapter), we also have to deal with crowds. This is not always so terrible. If you vacation in places where families are common, it's easy to hand your camera to an amenable passerby and ask him to take a shot of your family. And sometimes the reactions of people in the background can add to a picture. You may even want to take crowd shots; sometimes faces clustered together can make interesting patterns.

If your trip includes visiting museums or churches, don't waste your film and flash by shooting indoors. Unless you're in a very bright space you'll need the flash, and it probably isn't powerful enough to illuminate a meaningful area of any room. Many museums also forbid flash photography. You just won't be able to shoot your daughter standing next to the Mona Lisa. This is another reason to buy some postcards.

Whenever you visit a new place, you notice differences. These differences are what you look for in a vacation, and they're worth photographing, too — not just the major attractions, but also the little things that are part of daily life. Unless you travel in the United States and stick to nationwide hotel and restaurant chains, your children are going to have some new experiences. Be on the lookout for them. Maybe you're renting a van for a driving trip. Snap a picture or two of the van and a few with the children sitting in it. (Kids love to "drive" a stationary car.) It may not be a beautiful photograph, but it represents hours of your trip and will jog your memory later on. For most kids, staying in a motel is a tremendous treat, so take a picture of your room. Put the kids on the bed and get down low to force the perspective. Even if you feel a little silly whipping out your camera in a restaurant, you'll never see those other people again and it's worth getting a shot of your children's first taste of some local specialty.

The children will love these pictures, too, and that matters. Most of the time when I take pictures, I don't think Ben cares one way or the other. But by the time children reach their preschool years, they love looking at the visual record of things they've done. If you are your family's official photographer, you owe it to everyone to take some pictures that you might consider clichés. These shots of the motel room and the car can be a lot of fun for a child to look at or show to her friends. If you go to Disneyland, you'll see dozens of parents lining up to take their child's picture with one of the characters that roam around. Sure, it won't be an original shot, but your child will love it. (This is one reason you need to take extra film with you: you can't anticipate what your children are going to think is important about the trip.)

Camper in the
background, campfire in
the foreground, and
marshmallow chef in
between — a classic
vacation shot.

How to Shoot

A few technical pointers for some of the situations you're likely to encounter on vacation can improve your travel photographs. As I mention above, most of us take our vacation when school is out, and that usually means summer. The problem is that midsummer light is not the most interesting light. It can be harsh and cast dark shadows. At midday, when you will probably be outside, it's at its least flattering. (Some automatic cameras will compensate for this with fill-flash — see chapter 3, "Light.") It's not realistic to expect parents to hustle their families outside to take pictures in early morning light, but late afternoon and early evening can be quite magical. With daylight savings in effect, sunlight can be adequate even after dinner, and the spell of staying up late on vacation often ensures you extra-good behavior from your kids.

At the Beach

To millions of Americans, summer vacation means the beach. The combination of bright sun and light-colored sand requires a little special care. Try to avoid shooting at midday, because the light is so strong and the shadows so small. If any shade is available, it will make for more flattering pictures, especially if it's the diffuse light under a pale beach umbrella. But say your children have built a huge sand castle and the tide is coming in. You don't have a choice. The bright sun reflected off water and sand will probably mislead the camera's meter. If it's possible, get close to the children's faces and let the camera read from their flesh tones; then, keeping the shutter button pressed halfway down, recompose the shot. Check your camera manual for details. This is such a common situation that most manufacturers offer ways to deal with it. While you're shooting, look carefully at the shadows on the children's faces. You may want to reposition them with the sun behind them or activate your flash to fill in some of the shadows.

You do need to be very careful with your camera at the beach. Sun and salty, damp air are terrible for the inner workings of a camera. If you drop your SLR in the sand, you can do a lot of damage. One of my assistants, who used to work in a camera shop, recommends that families leave their SLRs at home and take disposable cameras to the beach. The picture quality is acceptable, and you'll be worry-free.

On the Slopes

Snow presents some of the same difficulties as sand, especially on bright days. Again, you have a pale, highly reflective surface that can fool the camera's meter. Most compacts will automatically make an exposure that turns the snow mid-gray and darkens figures and faces unacceptably.

If I'm shooting with a compact camera, the tactic I end up using most on snowy days is getting as close as I can. As long as there is more child than snow in your frame, the camera will meter correctly. Or sometimes you can use scenery in the same way. A stone wall breaking up the expanse of white can help ensure that the meter is reading middle tones rather than the white of the snow. Just remember, if the snow is what predominates in your viewfinder, your compact camera will turn it gray.

This is one of the situations when the flexibility of a manual camera comes in handy. You aren't limited to close-ups. Even at a distance, you can make sure the meter is reading the skin tones rather than the snow, and you can adjust the exposure so the whites stay white and the subject is correctly exposed. It might be helpful to refer to your manual, since various models handle this kind of lighting situation differently.

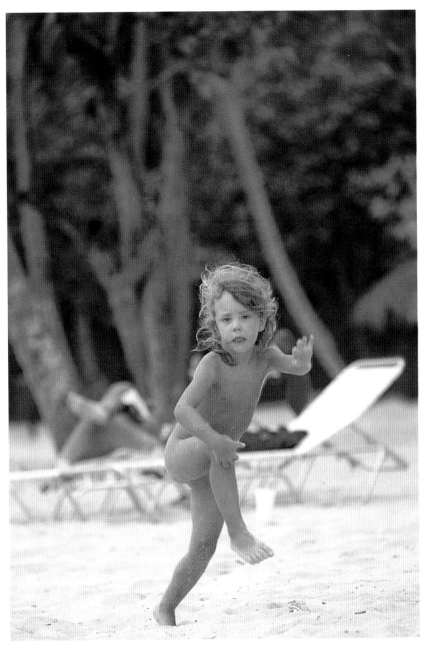

This girl's animated dance shows her excitement at being on the beach in an exotic place.

Action
Photographs

This is what I mean by
the peak of the action. I
love the look of triumph
on James Phillip's face.

Taking any kind of picture of children usually requires fast reflexes, but trying to capture them in action is even more of a challenge. Still, getting good results is very rewarding, especially if sports are important to your child. All of the effort and concentration that go into playing a sport deserve to be recorded.

Most of the time you'll get the best pictures by capturing the peak of the action. If you think about it, you'll realize that there are certain crucial moments in every athletic activity — the minute the pitcher lets go of the ball, the horse jumps the fence, or the little guy who's it tags his buddy. To catch that, you have to be ready.

Taking action photographs is another one of those activities in which thinking ahead and doing a little planning can make all the difference in the results. To get the best action photographs, you need to *understand* the action. You can't get good pictures of baseball players, for instance, if you don't have any idea of where the ball might go next. But if you understand the sport your child is playing — even if it's just capture the flag — you also have a better chance at managing the three basic concerns of action photography: position, focus, and light.

The Best Vantage Point

Let's start with **position.** In most ball games, for example, you're going to want to keep the ball in the frame. Where do you have to stand to do that? What's the most exciting spot in a basketball court? The basket, of course. Where do you want to be if you're photographing tennis? Near the baseline. Some of the best pictures of ice hockey are taken near the goal cage. Sometimes you may have to get special permission to stand where you want to. Your child's coach will probably let you down onto the sidelines, though, if he or she understands that you won't get in the way.

Standing right at the edge of the slide and shooting upward toward the open sky in the background convey some of the same feeling of height the slide must have for a toddler.

Faces aren't always the focus when you're shooting action. The point here is being airborne, and I caught James Phillip just before his outstretched foot touched the ground.

While you're at it, consider using different angles. Don't rely on holding the camera at eye level. This is especially important with small children; squat down to get to *their* eye level or, for an even more interesting vantage point, get below them. You'll add a little drama to the shot.

As you're moving around to find the best spot, don't worry about losing sight of your child's face. Action photography may be the most objective kind of picture taking parents do. It's full of inherent drama that is visible in the child's body, too. You can read tension or effort in the way a child holds himself. Your child's back can be as expressive as his face at moments like this.

Sharp Focus

Of course, whatever you shoot, you'll need to consider **focus.** This is one of the major technical challenges of action photography. It's also an area where advances in technology can help you out. The most expensive, elaborate automatic SLRs can focus for you under incredibly challenging conditions. At the other end of the spectrum, it requires a lot of skill to adjust the focus of a manual camera on fast-moving bodies. But there's a paradox here. Although we usually want our pictures to be in focus, blurring is what gives a sense of motion to the image, so sometimes tack-sharp focus in your action pictures is undesirable. Yet the blurring has to be in the right place. Imagine that your son is riding toward you on a tricycle. If he's in focus and the bushes behind him are blurred, it looks like he's moving fast. But if the bushes are in focus and he's blurred, it looks like a bad picture.

Unfortunately there's no shortcut to mastering focusing; only through hours of experience can you acquire the skill. However, there is a technique that can improve your chances of getting sharp pictures when you

want them. It's called prefocusing. Being in the right spot is crucial here, because what you do is focus on the place where you know something important will happen. For instance, you might stand near the finish line of a race. As you wait for the runners to arrive, you put your camera to your eye and focus it on the spot where they're going to appear. Keep your finger on the shutter button, and the instant they arrive (or, better, an instant before), you take your shot. It

Although Hunter's face is out of focus, this shot succeeds because the blurring conveys a great sense of motion. The shutter speed, 1/30, was slow enough for the flying snow to appear as streaks on the film.

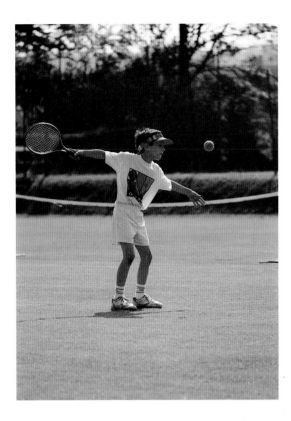

It takes a fast shutter speed and fast reflexes to get a shot like this one, where the racket, the player's face, and the ball are lined up on a strong horizontal.

may take some practice to get this just right, because in the second between your spotting the runners and the camera shutter actually opening, a lot can change. The more often you use the technique, the better you'll be able to anticipate just when to press the shutter button.

Light on the Subject

One of the hardest things about action shots is getting enough **light**. There are several reasons for this. First, your shutter speed needs to be fairly fast to stop the action. Though 1/250 second is fast enough for most children running all out, you'll need about 1/1000 for something like a teenager's powerful tennis serve.

A fast shutter speed would be fine if you could use a big aperture, but very often you can't. For one thing, a wide aperture gives you very little depth of field. That means focusing has to be extremely precise. You really can't count on that when you're photographing action.

A lot of photographers like to use telephoto lenses for action. It makes sense. You can rarely get really close to what's going on — you'd be in the way — so to get interesting shots with figures that fill the frame, a long lens is a big help. And because many telephotos have smaller maximum apertures than shorter lenses, you can't open up that much to get more light. (Another important point about telephotos is that they tend to exaggerate your own movement, meaning that unless you've got some support, like a tripod, you need a shutter speed equivalent to the length of the lens. In other words, if you're using a 200mm lens, you'll need to shoot at 1/200 or use a tripod.)

What this all adds up to is: fast film. Unless you're guaranteed brilliant sunlight for your action shots, you'll need ISO 400 or 1000. And if you're shooting indoor sports, you might have to go up to 1600. Remember, flash is no use to you when your daughter is yards away in the

middle of a skating rink. And if there's no natural light and you aren't sure how the venue will be lit, shoot fast black-and-white film (ISO 400 and up) to avoid problems with color balance.

So far I've talked about how to catch the peak moment in action or sports photography. It can be a great challenge, and you can get some very rewarding results this way. But I also want to suggest some less conventional ways to think about photographing action. If you can fill the frame with a tightly focused shot of your son's tennis serve, you're fortunate, but that's not the only thing going on at the match. For instance, maybe Mom is sitting there in the stands chewing her nails, or perhaps the spare rackets and balls and bags have been flung down to form an interesting composition. Maybe there's something about the pattern of the net and its shadow on the court. These elements are all part of the scene. They can't replace the action, but they can add to the overall memory of the event.

Another opportunity for interesting photos in action photography is the period *before* the action begins. Kids get very involved in any physical activity, whether it's a team sport or running around the backyard. Even if they're just sitting on the bench waiting to go into the game or watching their friends jump rope, their emotions show in their faces. They may be tense or gleeful, but the important thing to you as a photographer is that they will be concentrating. They probably won't be paying any attention to you, so this is the perfect time to get unself-conscious pictures of your children.

Taking action shots is not easy. You may need to shoot a lot at first. Expect to use a good amount of film. It takes a while to get used to anticipating the moment. I sometimes panic and shoot wildly, ending up with lots of arms and legs and confused, useless shots. But you will learn to wait and recognize the instant to shoot. And your action pictures of your children will show that amazing movement that's such a big part of childhood.

I shot the children running into the pond at 1/500 to freeze the leaping bodies and the flying drops of water.

Portraits

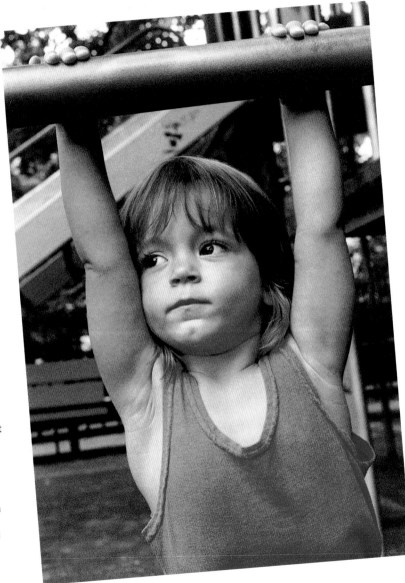

The setting for a portrait can be whatever will make a good picture. Sometimes with small children, familiar surroundings that offer some distraction mean a more relaxed and productive session, even if the results are a little more informal.

So far I've written a lot about capturing kids on the run and reacting quickly to what they're doing. But there is a different way of taking pictures of children: believe it or not, you can sit them down and do a portrait session.

A lot of parents probably feel that they'd rather go to a professional photographer once in a while to get a reliable likeness of the family than try it themselves. But you're the one who knows your children well. You can set up a portrait to reflect their interests and personalities. They'll respond to you in a more intimate way than they would to a stranger, and that response will show in the pictures.

First, let me explain my definition of a portrait. I don't mean a photograph where the family sits in a row, facing forward, trying not to look self-conscious. I'm talking about any picture that acknowledges the camera. There's a certain formality to it, and it may be staged or include props. Basically, the people in it are *having their picture taken.*

You won't get the same results at home that you'd get from a pro. But you will get something unique. And a family portrait session can be fun if you go about it in the right way. The suggestions here are not the last word on shooting portraits. Think of this chapter as a place to begin and use your imagination. When you're shooting portraits, you'll have more control than at any other time with children. Use it to your advantage — loosen up and be more creative, take some risks.

Getting Ready to Shoot

The first point (and though I hate rules, I think this might be one) is to allow plenty of time. Give yourself a whole morning or a whole afternoon. You know how, when you're rushed, children always take twice as long as usual to do anything? Make sure there's all the time in the world for dawdling as they put on their clothes or have a snack, since they're sure to announce

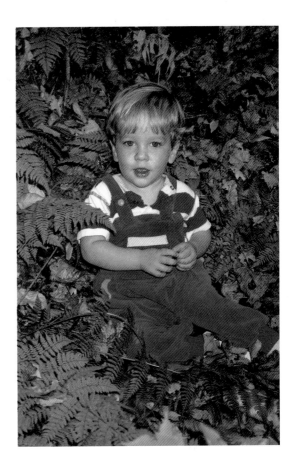

The irregular pattern of dead leaves and ferns makes an interesting but neutral background for Tim. I took this picture with a compact camera, and to my surprise the flash went off. You can see the white catchlights in Tim's pupils and the bright highlights on his nose and forehead.

The strong diagonal composition, the dramatic light, and Eitan's direct smile combined to make this a portrait I was really pleased with.

that they're starving just when you're about to start. And you'll need time to fiddle around with that roll of film that just won't load correctly.

Don't expect to do this alone. While one grown-up is setting up the camera, background, props, or whatever, the other one can keep the children on track — get them dressed, keep them entertained, keep them clean. An obvious partner is the non-photographer parent, but a close family friend might be even better, since kids often behave better around people they aren't related to.

I've said it before, and here I go again: think this through ahead of time. In the weeks before you actually do your photo session, pick your location. Don't feel you have to stay in your house or your yard or even in your town. It's worth getting into the car for a drive to get a great location, and it makes a fun outing — you could pack a picnic.

You'll notice I'm taking for granted that you'll shoot outdoors. The reason for this is simple: light. The one technical thing a professional photographer has that you don't is an array of studio lights. He can set them up to bathe faces in a warm glow. He can fill shadows or halo heads. He can make sure the light won't be yellow, and he will never take pictures with red-eye.

If you do want to shoot indoors, you're going to have to work out your lighting very carefully. I wouldn't want to rely on the harsh light from a camera's flash for a portrait, but you'll usually need light other than what's available from the windows (unless you're lucky enough to have a skylight). Regular incandescent lamps can be moved around, but they'll give you a yellowish cast unless you use tungsten-balanced film.

So overall it's much easier just to go outside and rely on natural light. As you're thinking about backgrounds, remember that you want something that's not too complicated or distracting. Your children are the main event. A

beach out of season, a big granite stairway, a group of trees or shrubs, or an interesting wall are some good choices. As you consider backgrounds, remember that you don't want other people wandering into the frame (which can make shooting in a park agonizing). Again, look hard as you're scouting. Don't ignore the parked cars or the electrical wires that we usually overlook. Bear natural hazards in mind, too. More than one child has gotten poison ivy from sitting in a beautifully leafy spot in the woods.

Once you've found your spot, imagine how you'll position the children. Can they sit directly on the ground? Will they stand? Where? How far away will you be? Where will the light be coming from? Will their faces be in shadow? Get your grown-up helper into the children's position for a minute. What is the light like? You may need a reflector of some sort. Usually a white towel on the ground or a piece of white cardboard (held by your assistant) can bounce enough light back onto faces.

I was attracted by this girl's stillness and her slightly melancholy look. The simple composition and dark background add to the timeless quality of the picture.

Equipment Check

If you have a choice of cameras, this is an occasion when an SLR is the best bet. You have the unusual luxury of time here. You aren't chasing your subject around, so a manual camera won't be a disadvantage. More important, the viewing system of the SLR will make it easier for you to frame and compose your shot. What you see in the viewfinder, remember, is what you'll get on film.

A portrait session is also a time when the greater control and flexibility of some SLRs really come in handy. For instance, you may want to experiment with blurring the background a little to make the children stand out more. You can do that by shooting wide open, at f/2. On the other hand, if you want everything — background and children — in sharp focus, you can use a slower shutter and close down your aperture. Or you can try both ways and see what works better when you get your prints.

I strongly recommend using ISO 100 or 200 print film. Print film is more forgiving with bad exposures, and slow speed will give you minimum grain. Try shooting at least one roll of black-and-white for variety and a more nostalgic look.

Focus is also very important, so if you're at all uneasy about your focusing ability, close down your aperture to f/11. With a smaller aperture and more depth of field, you won't have to worry so much about making sure everything's sharp.

I think you're best off sticking with a 50mm lens unless you're very comfortable with something else. This is not the time to start experimenting. It's true that an 85mm-to-105mm lens is often used for portraits, but I'd leave that for the really confident photographer. For one thing, the depth of field is limited with longer lenses. And if it's not a very fast lens, you simply may not be able to get enough light.

One piece of equipment that could make your portrait duties easier is a tripod. You can rent one from most camera stores if you don't own one. In this instance it's worth having reliable support for the camera. If you use a tripod you can set up your shot, dart out and reposition one of the children slightly, and go back to your position. A tripod also ensures that the camera is straight, so you won't have slanting photos. What's more, it gives you the option of getting in the picture yourself, using the self-timer. (I'll talk more about that later in the chapter.) And if you are set on using a telephoto lens, the support of a tripod means you can use slower shutter speeds without worrying about camera shake.

I'm sure I don't have to remind you to check your camera's battery and make sure you have enough film. Count on shooting four or more rolls in a session like this.

The Subject Is Children

I've gone on quite a bit without even mentioning the children. Where are they supposed to be while the photographer parent is setting up the camera? Anywhere but in front of it. You want to do everything you can, including possibly focusing, before you get them into position.

Probably the trickiest part of the entire photo session will be handling the children. You want them to be cooperative, so you need to make the whole thing enjoyable. But you don't want them keyed up and jumping around. So whatever they're doing while you're getting ready, it should be pretty calm — a game, puzzles, reading, or singing, not playing cowboys and Indians, not getting their clean clothes filthy.

Of course you want everyone to look neat and attractive, but to make things easier all around, I'd suggest comfortable outfits. Make sure the children have worn the clothes before, so you don't discover itchy labels or tight waistbands on photo day. While you don't need

The success of a studio portrait like this one depends on the photographer's rapport with the sitter. Your subject's reaction to you is what shows in the camera. Stephanie became very animated when I asked her about her recent birthday party.

to dress them exactly alike, keep to a uniform palette. Don't put your daughter in pastels and your son in crayon-brights. Pale colors are generally more flattering to skin tones.

You also need to distract them a little from the momentous occasion. When children reach the age of three or four, they often develop a stiff grimace that they think is smiling for the camera. This is something you want to avoid. Maybe your assistant can read to them or tell a story or even knock-knock jokes. Try to keep your directives to them to a minimum, because every time you say "Sam, put your arm down," they freeze up again.

The key is to get them talking about what they can relate to or what interests them. I may ask a question about Sesame Street or a recent movie older children might have seen. I want to

I shot the more solemn portrait of these girls early in the session. They were cooperative but still a bit reserved. By the time I gave them the dark glasses, they were ready to cut loose and make silly faces.

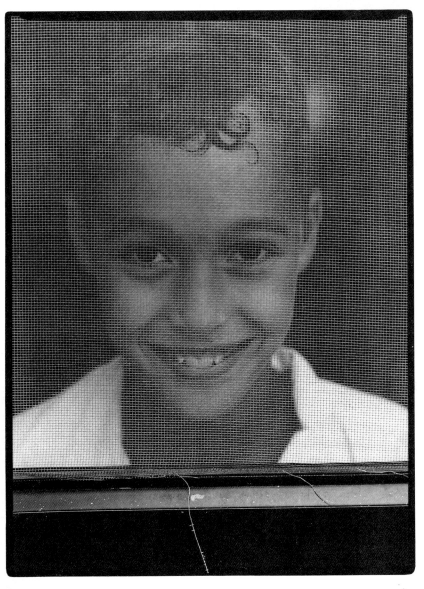

The fine mesh of the screen door in front of the boy's face offers an interesting textural element.

take their attention off the camera so that they're interacting directly with me. Ultimately, this means they'll be interacting with whoever is looking at the picture.

If you're a real purist you won't want to bother with this, but some professional photographers, as I mentioned in chapter 4, "The Subject," like to introduce props. They give the children an object to focus on, which is very helpful. And if the prop is something the child is fond of, like a stuffed animal or a prized baseball glove, that's nice commemorative information. Hats can be fun, because children like to assume new personalities — suddenly they're spies or sailors or nuns. (Look out for shadows on their faces, though.) A new object will occupy a child's attention for a while, but you probably won't be able to see his eyes as he examines it or plays with it. The choice is up to you, but if you do use props, make sure they're large enough to read clearly in the camera. Otherwise you'll have an unidentified object in your child's hands.

Another important point is pacing the photo session. You'll need to provide some variety. If you are using props, introduce them halfway into the roll. Have the children get up and switch positions (maybe with a little Simon says in between to stretch their legs). As a rule, I start by talking quietly to the children, so that I can get a series of low-key photographs. Bit by bit, I lead them on into being silly, maybe with songs or riddles or ridiculous words. As they get loosened up, the session becomes more physical. The kids grow livelier, and I see more and more funny faces. The crucial thing is to be sure you've gotten all the mellow shots you need before you start this, because once the children are wound up, you can forget about settling them down again.

A great way to end a photo session, if you have a little film left, is to use the self-timer and get into the picture yourself. If your shoot is going well, the children will probably be tickled pink at you scurrying around to get into the picture. This device makes most people somewhat nervous. Though today's cameras give you plenty of time to get into position and grin, it's hard to remember that.

There is one age that's especially hard to handle for portraits. As you might have guessed, it's the toddler stage. Once a baby is mobile, it's hard to keep her from lunging toward the camera. The frustration of having to sit still may upset her. And older toddlers can be so quixotic that they may insist on wearing their rain boots or just refuse to get in front of the camera at all. Keep it quick and don't get too elaborate when you're planning on photographing a toddler. If you've gone to great lengths to search out a great location and gotten up early to catch the morning light, you'll be furious when your child won't cooperate.

Holiday Greetings

The one thing most people want to do with pictures of their children is send them out as greeting cards for Christmas or Hanukkah. It's so much fun to see pictures of your friends' children, and you want to share your pride in your own kids. Taking pictures for a holiday card is exactly the same as any other photo session, except that you may want to use different outfits or props.

It takes a pretty serious commitment, but an annual holiday photo session can be a wonderful tradition. Do it in the same spot each year, at roughly the same season. It's great to look back and see how the children have grown in relation to the background. Or include the same prop each year, to provide the same sense of scale.

This change-of-address card was sent by a friend who is a photographer. He printed it himself on a photographic postcard, but a well-equipped lab can do the same thing for you.

This was an invitation to a first-birthday party. The parents had the photograph printed on photographic paper, then folded and cut it out. The invitation is written on the inside.

Because this is what I do for a living, I'm inclined to do fairly complicated things with holiday pictures. One year I built a huge box and stuffed it with tissue paper and placed Ben in it as if he were a present. I've seen cards with children dressed as Santa's elves or as reindeer. At a certain point, though, your children won't let you dress them up anymore, so if you want continuity, stick with a more natural-looking setup.

If you decide to send out a photograph at the holidays, you can choose from a variety of formats. Most photo finishers offer prints with some kind of standardized message printed on them. This option is very inexpensive and easy. Though the cards are hard to write on because of the glossy finish and don't include a lot of room for a message, to busy parents that may be an advantage. Well-equipped photo labs can usually print black-and-white photographic postcards for you. It's a more unusual option but still inexpensive. If you just want to send loose reprints of favorite shots, you'll find that most commercial greeting cards are sized to enclose a 3" x 5" print. Sometimes museum reproduction cards come in odd sizes, so be careful to avoid narrow rectangles or other unusual shapes if you want to enclose a picture. Also, certain stationers and photo-supply catalogs offer cards that frame your pictures with some festive motif. They're more expensive and require a little more assembling, but some of them are very handsome.

Even if you usually take your photographs to be developed at a handy one-hour lab, I'd recommend taking more care with your batch of portraits. Since a poor developing job will mean you can't get a good print, it's worth spending a little extra time and money to take your film to a reputable photo store. Remember, too, that photo stores can sometimes correct things like color balance of skin in the printing, so the higher price may be worth it.

Ben's grandmother gave him a Santa Claus suit for his first birthday, and a friend who is a stylist lent us the sled. The resulting Christmas card (above) was so funny that we were inspired to dress him up for lots of different holidays, such as the Fourth of July (left). We kept it up until he stopped cooperating, when he turned two.

Chapter 12

Candids

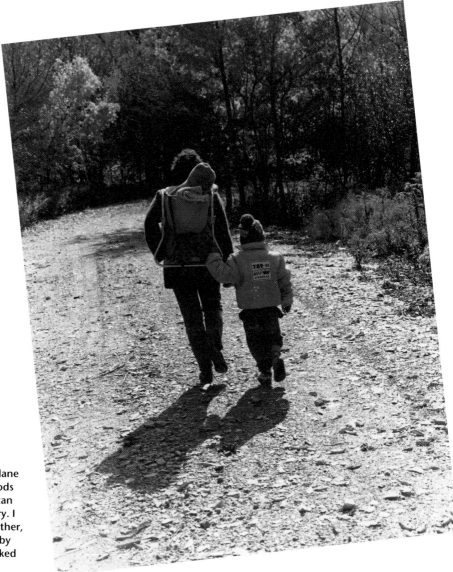

If you photograph
something as mundane
as a walk in the woods
on a cold day, you can
fix it in your memory. I
like the way the mother,
her son, and the baby
are all physically linked
in this shot.

No matter how busy parents are, they always manage to pull out the camera for birthday parties, vacations, and Halloween. But a lot of us tend to forget that everyday life is also worth photographing. When I look back at the photographs of my childhood, the ones that really capture that time are the snapshots of unplanned moments, like the kids in the neighborhood lined up in my backyard, or me as a baby, squeezing the neighbor's cat half to death.

A lot of parents say to me, "I took so many pictures when Emily was a baby, but now . . . ," and then they shrug. I understand. You get caught up in the whirlwind, and the camera gets dusty. Babies change from day to day, and you need to photograph them often to keep up with them. It's frightening how easy it is, with older children, to look up and realize six months have gone by and your daughter has grown two inches since you last took her picture.

I have a strong sense of how quickly Ben's childhood is speeding by, and I want to remember it. Since I'm a photographer, it's second nature to me to take pictures — not just of the special moments, but also of the ordinary ones. I'm hoping that someday, as I look through those boxes of photographs I've accumulated, I'll come across one that will take me back to age two, when he started making that funny face, or to that pair of overalls that he insisted on wearing even after he'd outgrown them. It's little things like that, the texture of everyday life with your child, that you can catch with candids.

Everyone takes pictures of their children in the bath. It's a good time to use black-and-white film, which records the subtleties of skin tones very well. Shooting wide open here blocked out details like the faucet while maximizing the light from the window.

Of course the difficulty with photographing these things is that you can't really plan ahead. Throughout this book I've been suggesting that thinking things out in advance can give you better pictures, but the point about candids is that you're concentrating on the unexpected. Still, there are ways to improve your informal, unposed photographs. And a lot of them have to do with anticipating the moment.

Be Prepared

The most important thing is that you should always be ready to take pictures of your children. I've said it before: you have to be able to lay your hands on a camera that's loaded with film and has a live battery in it. I make a point of keeping my camera in one place so that I don't have to search for it while that compelling moment vanishes. In fact, since I have the luxury of owning several cameras, I keep both an SLR and a compact camera loaded and ready to go.

Be sure to take pictures of your child playing at various ages, since the train phase or the Barbie phase won't last forever. You might also want to photograph monumental block constructions or any project that has required a lot of effort.

The flowers on this girl's bathing suit and the way she's holding the bucket on her head somehow suggested Carmen Miranda.

But loaded with what kind of film? That depends on the situations you'll be shooting. The chapter on film talks more about this, but you'll want to choose the film speed that will, on average, be best for your circumstances. For instance, I don't happen to use (or even own) a flash attachment for my SLR. This limits me to using natural light, indoors or out. So I generally keep it loaded with ISO 400 or 1000 print film to give me the greatest flexibility for shooting indoors. Unless you live in rooms that are constantly flooded with sunlight, you'll need to use a fast film if you want to do without flash. The compact camera, naturally, has automatic flash. So I load it with ISO 100 or 200 print film.

Now, I realize that most people won't shoot a whole roll of film at once. It doesn't matter — it's perfectly all right to let your camera sit, loaded, for a month or two. Most print film is quite stable, and as long as the camera isn't someplace hot or cold or damp, no harm will

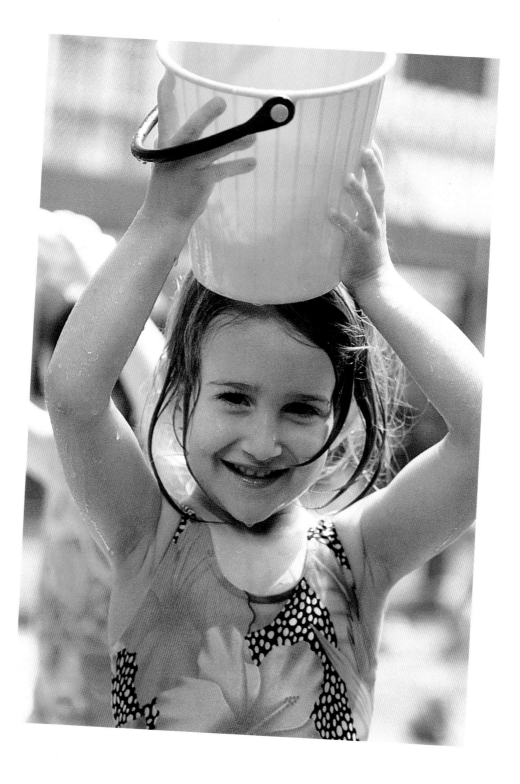

come to it. (You should get the roll developed as soon as you finish shooting it, though.) I once finished a roll of film that was in my husband's camera, and when it came back from the processor I saw that it had shots on it from our vacation of the year before. I have to admit that they looked fine, but we were lucky.

I would also recommend having a couple of rolls of both fast and slow film in the refrigerator so that you're ready for anything. When you put them in your camera, replace them just the way you would that backup box of Cheerios.

I also realize that there will be times when the film in your camera isn't going to be the best choice. Let's say you've shot eight frames indoors on your 400 film when it snows. You go outside the next day to photograph your children and their snowman. Fast film is not ideal for shooting in bright light. But there really isn't too much you can do about this except shoot at a very fast shutter speed to avoid overexposures. Though the snow photographs won't be your best ever, at least you'll have them, and you'll also have the shots of the Barbie fashion show at the beginning of the roll.

There are some events you can anticipate a little bit — not big events, just everyday things that would be nice to capture on film. Suppose you've planned to do some leaf raking over the weekend. Raking means leaf piles. Leaf piles mean kids rolling in leaves. To get ready, buy some slow film along with those trash bags you'll need, and maybe even finish off the roll of fast film in your camera. Or perhaps you plan to bake cookies. It might not have occurred to you, but you can take a break to shoot five or six frames of the kids mixing the dough. Just get the camera out along with the cookie cutters.

I had fast film (ISO 400) in my camera when I shot this snow scene. Fortunately it was an overcast day; the high-contrast film would have been hard to expose in bright sun. I metered for the boy, so that I would get a good range of skin tones. The tradeoff was losing some detail in the snow.

Nothing is more precious than those moments when children are collaborating on their "work," which is exploring their environment.

Your Point of View

In terms of shooting technique, you can divide candid situations into two categories. In the first, the child's face is the most important object. You may be inspired by the light on your child's skin or by his expression. Here the background isn't very important, so get close and fill the frame with your child's face. If you have a manual camera (and are pretty confident about focusing), shoot wide open to blur the background.

In the second category of candid shots, the photographer includes more information. These pictures tend to be of the little occasions, like a trip to the zoo or setting up a lemonade stand. You'll need to pull away a little more to get more background into the picture, and you'll

need to be a bit more patient. Keep the camera to your eye and wait for the moment when the composition looks right to you. Move around to find the best angle. Keep concentrating on what you see through the viewfinder, and shoot a lot of frames. The way children move, your composition can change completely from one moment to the next. I often shoot a series close together, and when I get the prints or slides back, there will be four bad shots leading up to one great one, and then four more bad shots afterward. This may sound like a terrible ratio, but believe me, it's completely normal.

Sometimes you can shoot without attracting attention, and sometimes children act up when they see the camera. But occasionally the child will look right at the lens without stopping what he's doing, to make sure you know he's *letting* you take his picture.

I should mention photographing siblings, because, as in every other aspect of family life, the number of children complicates logistics. One sensible solution to the problem of photographing more than one child at a time is simply to shoot more. Chances are good that with two children in the frame, one will have her eyes shut or be looking in the wrong direction. If you take a series of pictures of one situation, you improve your chances of getting acceptable shots. Parents of more than one child may also have to do more directing, even for candids. Otherwise it's hard to get two children into the same shot.

One mother of two children says that she really has three young creatures to look after: her two sons and their relationship with each other. This relationship is something else you

This is one of those rare shots that capture a typical sibling interaction with no awareness of the camera.

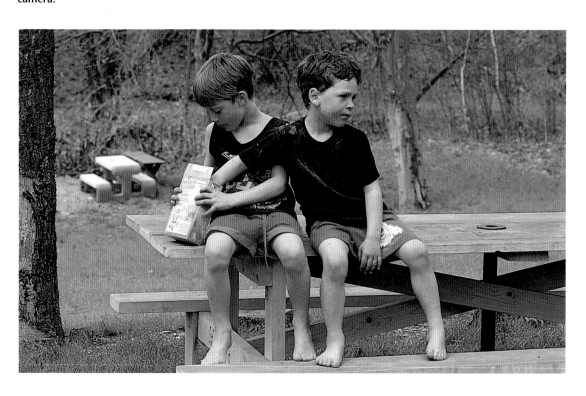

will want to capture as your children grow, and it can be elusive. Siblings don't always love or even like each other. Jealousy, intolerance, or dislike may alternate with love and acceptance. As a parent, stay on the lookout for the moments of intimate interaction that you can photograph quickly and unobtrusively, maybe at a distance. And don't neglect to take photographs of each individual child as well.

It can also be fun to hand the camera over to your child sometimes. This works best with an autofocus camera, of course, and most SLRs will be pretty heavy for a preschooler. So a simple compact is ideal for a child to use. One as young as three will really enjoy taking pictures of his or her world. (Show some of your own shots first as an example of how to frame people's faces.) You get a startling new view, too, when you see how your house looks from three feet off the floor. Kids can often get excellent shots of adults, because the grown-up is responding to the child behind the camera, which means a warm, relaxed expression on the adult's face.

There are also events in family life that you can't prepare for at all, things that are incredibly cute or photogenic or that constitute landmarks in a child's life — the day your older child decides to put on the baby's clean diaper, or the day the baby discovers her toes. These are the times when you just grab the camera and shoot what's in front of you for as long as it lasts. Time is the crucial element here, which is why you need a camera always at the ready.

Emily and Ben were playing Superman when Ben got chilly. Children's natural protectiveness toward each other is often short-lived, so I was glad to have the camera handy.

The Beauty of It

I've talked in other chapters about training your eye. I don't want the idea to sound pretentious or difficult, because it isn't. Training your eye involves building an extra level of awareness. You can learn to distance yourself a bit from your children and see them from an aesthetic point of view. Sometimes this is easier to do with other people's children — because you're not so attached to them emotionally, it's not as hard to judge when a picture of them is worth taking. So try to make a point of taking more pictures of your children's friends, as an exercise. It can help sharpen your awareness of what to look for in a composition and what your own photographic taste is. I personally respond to strong shafts of light, and some of my favorite pictures of Ben are really pictures of light. As your sensitivity to the way pictures look increases, you'll find compelling photographs in everyday life.

Finally, there are a lot of things about life with children that we take for granted. Those attachments they have to inanimate objects, like a teddy bear or a toy train or a flashlight. An older child's "collection" (I have a friend whose son keeps dozens of cherished pieces of gravel in a toy safe). The plates and cups they use before graduating to grown-up dishes. Their clothes. Their beds. Their rooms. Getting dressed. Brushing their teeth. Getting a haircut. It's all this everyday stuff that makes living with children wonderful, and this is the stuff that tends to escape our memories.

From time to time, though it may sound odd, I take a couple of pictures of Ben's closet. I know a woman whose son has a lot of stuffed animals with names and a complicated kinship network. She photographed them recently, lined up on her son's bed, just to remember them. You might take your camera out to meet the children getting off the school bus one afternoon, or slip it in your bag as you take a child with you to do the marketing. It's possible to take good pictures of anything. And remember, the photographs we regret are the ones we missed, not the ones we took.

Cody's posture, and the delicate position of his left hand, say it all — he longs for bubbles but doesn't like the way they feel on his hands. Bodies can be as expressive as faces.

Chapter 13

Video Cameras

You'll find that many
principles of good still
photography also apply
to videotaping your
children.

I am a still photographer, and I think the majority of parents spend more time shooting still photographs of their children than using a video camera. But video cameras are becoming more and more popular. Many parents do have trouble taking advantage of the real strength of these devices: that they record motion and sound. That makes it possible for us to capture moving images of our children, and to capture their voices. This is the closest technology brings us to preserving the essence of a person at a certain stage. It's a tremendous thing.

You can take two different approaches to shooting video. One is to make a story out of each session. You can regard it as a film project, shooting from different angles and editing your raw tape into a polished product with a real dramatic shape. This requires a big investment of time, though, and access to equipment that most parents don't own.

The more common approach is one that's simpler for parents (whose spare time for editing projects is nonexistent) and also for beginners. It's a more journalistic way of looking at things. In chapter 8, "Milestones," I talk about just capturing events without having expectations of taking beautiful pictures. I think the great value of video for most busy parents is helping you remember. We spent Christmas a few years ago with some friends, and after everyone had opened their presents, my husband, Fred, picked up a video camera and went around the house quietly recording the aftermath. There I was, feeding Ben in a high chair, my mouth opening with every bite I shoveled into his mouth. There was my friend Susan, bending over, cramming the torn wrapping paper into a trash bag. (Fred shot her from behind.) There was Scott, reading the newspaper in a daze. Those images are indelible, thanks to the videotape.

What's This Button For?

I'm not going to discuss the operation of video cameras in any detail. The technology is still so new that there are lots of different models on the market. Though most people use camcorders, some people who got into the act early have video cameras, which function with a separate VCR. There are several different film formats, too. You need to refer to your instruction booklet to learn the operation of the camera. Shoot a random cassette or two just to get used to it, before you film anything you want to keep. If you're thinking of buying a video camera, shop around for one that's comfortable for you. (Be sure it also records in low light.) I have small hands, so I prefer the more compact models, but Fred finds it hard to keep the little ones steady. Even if you think one member of the family will be the principal camera person, make sure you are both at ease with the equipment. It would be a real pity to have years of tapes with one parent missing.

Though video is more complex, it shares some aspects with still photography. You have a lens, and tape (which replaces film), and light puts the image on the tape. The lens can be focused. It can be zoomed in and out to different focal lengths. And most important, you compose your frame in a similar way. Composition is a basic point, but I don't think most people really concentrate on this when they look through the viewfinder of a video camera. The novelty of the whole thing makes them jumpy, and they shoot at random. It's the biggest mistake they make. Remember that the same photographic principles apply here as to still photography. Really *look* at what you're seeing. Are you cutting off the top of people's heads? Are there disembodied limbs poking into the frame? What about the background — is there anything there that you're going to regret

later? Is the horizon level? A tilting video camera can really give the audience vertigo. Look these things over very carefully before you press that record button.

You may not be able to shoot beautiful tape when recording family life. Most video cameras usually focus on the center of the frame, for instance, so you probably can't avoid centered compositions. Keeping them clean and uncluttered, though, should always be at the back of your mind.

In some ways, you have less to worry about technically when you're shooting video. Shutter speed isn't an issue, naturally. Neither is aperture or depth of field. And most video cameras are sensitive enough to cope with a wide variety of lighting situations. The exception is backlighting. As with still photography, strong backlight fools the camera, and you will probably need to either diminish the light source behind your subject or provide extra light in front of him or her.

Ready, Roll 'Em

You don't have to deal with shutter speed or f-stops when you're shooting video, but you do have to cope with something even more important: time. Videotape is continuous. You can shoot for a minute or half an hour.

The beauty of this, as I've said, is that you can record motion. The danger is that your power to irritate or bore your audience increases enormously.

One reason for this is the self-consciousness of your subjects. Their stiffness comes across even in still photos, and it's enormously magnified on video. Most of us know how it feels to have that big black thing pointed at us with a person behind it saying, "How are you doing today?" We want to run away.

The best way to handle self-conscious subjects is the obvious one: make sure their attention is focused on anything but you and your camera. For instance, say you're filming your parents' arrival at the airport. You've brought the children along, and you want to film. You scan the crowd to see your parents coming. When they spot you and the kids, their faces light up. They hurry forward and give the kids a hug. Then they stand up to greet you. They notice the camera; that's when you stop recording, just before their faces freeze. Or say you want to shoot a little segment of your daughter practicing for her clarinet solo. She gets set up to practice, saying, "Oh, Daddy, go away." You keep the camera to your eye, waiting until she's so absorbed in her practice that she doesn't notice you. And that's when you start filming.

A word here about sound, because it's an important component of videotaping. We're all familiar with sound bites, those ten- or fifteen-second chunks of speech that politicians sometimes speak in. Regular people don't talk in ten-second chunks. Their sentences run on. Try to be aware of this and don't start filming in the middle of someone's sentence or cut her off before the end. The final tape will be choppy and confusing if you do.

Another reason video efforts are often boring is the temptation to let the camera run. It's easy to press the record button and keep recording in the hope that something will happen. One way to avoid this is to plan in advance.

Look at it this way. If you were shooting a party with still film, you'd ration your shots. You'd use some on the children arriving, some on the games, some on the cake. You'd be sure you had some film left to shoot opening the presents. With videotape, you probably won't run out of tape, but you'll get better results if you decide ahead of time what you want to capture.

The Tools of the Trade

With a still camera, each shot lasts a fraction of a second. With a video camera, the length of the shot is up to you. But it's still a shot. And it's still the basic unit of your tape. What you need to decide is what you'll shoot and how long each shot will be. For instance, you'll want to shoot the birthday-cake sequence of a party. You might start shooting as the cake is presented, and the shot might run until the candles are blown out. You might extend it to show the faces of the other children as the cake is cut. You probably don't need to show more than that. Try to remember what you had in mind when you planned this, and stick to it.

In fact, it's a good idea to write a shooting script ahead of time. This may feel awfully elaborate to you. I don't mean you have to have twenty pages complete with dialogue. But remember, what you're doing here *is* making a film. It will be much better if you map out what's going to be in it and how each subject will be portrayed.

That brings us to the whole notion of camera work. Some people watch movies and afterward go on and on about tracking shots and camera angles. I am not one of them. But when you put a camcorder on your shoulder, in a way you do become a filmmaker, since you use the same tools as the master filmmakers: long shots and close-ups and pans and fades. Most of us choose among them instinctively, and since we've seen so many movies and TV shows we probably naturally adopt some of the techniques used by professionals. Here are some of them.

Long Shot

This is a shot from far away. You can pack a lot of information into a long shot; often it portrays an exterior, like the outside of a building, or a signpost. Maybe the shot is of your subjects, but since you are shooting from far away, you put in a lot of background to show where they are. When this is the beginning of a film or scene, it's called an establishing shot. It's a very useful technique to adapt for home video.

Medium Shot

This shot is just what it sounds like. Generally the subject's whole body, or most of it, is in the frame. It's the basic shot used to convey information, and although it gets boring if used exclusively, it should predominate in your videos.

Close-up

The subject's face fills the frame in this shot. It's a good way to show emotions and reactions.

Pan

When the camera moves, it's called panning. A pan connects two subjects. For instance, it might be effective to use this shot if you're filming a baby taking its first steps. You film little Eddie toddling across the living room, then pan to his proud mother, holding out her hands to him with a smile. If you do choose to pan, be sure to do it slowly; otherwise you'll blur the subject. Your camera can't focus fast enough on what's passing in front of it.

Zoom

This is another very popular shot. When you zoom, you change the focal length of your lens, filming all the while, so the subject gets either larger or smaller. (Be sure, before you do it, that you're going in the right direction; nothing looks more amateurish than a zoom that starts out moving away and abruptly changes to zoom in.) Zoom lets you change your viewpoint without moving.

The combination of a longer shot zooming in to something closer is a great way to present a lot of information. For instance, you might

shoot a group of kids sitting at a table in someone's kitchen with a huge mess on the table. You're far enough away to set the scene in one quick shot. Then you zoom in closer to what the kids are doing — maybe you see some bowls and measuring cups and food coloring and vinegar bottles and a box of baking soda. Then you can zoom in even closer as one child adds a spoonful of baking soda to a cup of vinegar and suddenly the whole thing foams up all over the table. Then you zoom back to catch the kids' expressions. It's a logical progression, and you're telling a story very economically. Since zooming alone can feel very static, consider moving the camera, or panning, while you zoom. The actions complement each other and minimize the yo-yo effect of simply zooming in and out.

Narration

Video cameras pick up sound very reliably, so you may not feel that you need to talk as you're filming. But often some extra information from the cameraperson comes in handy. Remember, when your children watch this video in fifteen years, they may not remember where you were or recognize all the people in it. Set the scene when you're starting a new segment: in a matter-of-fact way, announce where you are, who's there, and what the event is. At the same time, though, refrain from telling your viewers what they can see for themselves. For instance, to go back to the science experiment I just mentioned: if you shoot a boy scooping baking soda out of the box, and the label can plainly be read through the camera, you don't need to say "Now Jim is putting some baking soda into the mixture." You could say, "Wonder what that baking soda is going to do?" because you're building a little suspense rather than telling them what's obvious.

There are some people who are at ease with an audience, and they can make narration a strong part of a video. My younger brother, Edward, got hold of a video camera at our last Thanksgiving and walked around interviewing everyone and commenting on what he saw. He was very confident and witty, and the tape is hilarious. Now, I don't have the personality for this kind of narration. Not many people do, and anyway, your hands are full with the camera. Consider using a separate narrator for your video, somebody who's at ease in front of the camera (most families, like mine, include at least one ham). You'd want to open with a shot of the narrator, so that everyone knows whose voice they'll be hearing. Give her or him a few sentences to say in front of the camera, setting the scene. Then she or he can talk throughout the video, as needed. If your VCR has an autodub feature, you can even add narration afterward, though a disembodied voice talking on your tape may be a little confusing.

There are two very important points that have to do with filming motion. One is simple: movement that starts in one direction must continue in that direction. In other words, say you film your son bicycling from left to right across the frame. As long as he's on that bike and you haven't filmed him making a turn, you'd better keep him going in the same direction, or he'll look as if he's madly bicycling back and forth over the same terrain.

The other point is a little harder to explain but equally important. When you're filming an individual or a group of people, you must stay on the same side of them as long as you're shooting. Think of it this way. You're watching a football game on TV, the Giants versus the Rams. The camera stays on one side of the field, so that during the first quarter of play the Giants will move only from left to right when they have the ball, and the Rams only from right to left when they have the ball. If the camera were

suddenly to switch sides, you'd be momentarily confused as to which team was which.

It's the same with most professional sports that are filmed: the camera remains on the same side of the action throughout the duration of the competition. The theory behind this rule applies to informal, nonsporting events as well. It's confusing for the viewer to see the same people flip to the other side of the screen.

To avoid this problem, remember the 180-degree rule. It states that you, as the camera operator, should draw a mental line, parallel to the horizon, just in front of your subject. You can move anywhere on your side of that line (known as the axis); that gives you 180 degrees to move around in. But if you cross the line, your subjects are going to switch positions in the film frame, and your viewers are going to be baffled.

Life As We Know It

Now that you know how to make a video that's interesting to watch, what should you film? People tend to use their video cameras the way they use still cameras: they bring them out for special occasions. Birthdays, family gatherings, school plays, all get filmed, and in between you leave the camera in the closet and forget what all those buttons are for. Or you buy the camera when the baby is born, get a lot of footage of a three-month-old trying to get her toes into her mouth, and lose interest.

These are both big mistakes. For one thing, children only become more fascinating. I know babies are adorable, but listening to an eight-year-old explain football to his grandmother on videotape will also be captivating. And special occasions may be picturesque, but there's a lot more to life. As I keep saying, it's the little things we really need to remember. If you've gone to the expense of buying a video camera, you should really *use* it. Make a full record of your children's youth.

You can shoot any of the occasions I cover in this book. A lot of the same advice will apply, particularly with respect to handling children. The video equivalent of portraits would probably be "talking heads" sequences, which feature children talking to the camera. As they get accustomed to this, and if you engage them in something they're interested in, they will lose their stiffness.

You can also shoot birthday parties and Halloween. With a video camera you can film the children getting ready to go trick-or-treating, which is a wonderful moment full of anticipation. At holidays, you can film parents trying to put together the elaborate presents that needed "some assembly" and the children playing with them afterward. You can take your camcorder on vacation and film your son's first ride on a horse.

Once you get comfortable with using your camera frequently, you can shoot home movies, too, writing your own scripts and using costumes and props. *How to Shoot Your Kids on Home Video,* by David Hajdu, is a very complete book that gives several sample shooting scripts for short films.

Many of today's video cameras are simple and compact enough for a child to use.

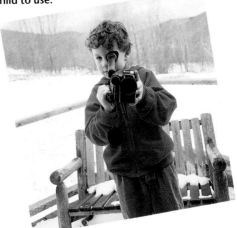

Bibliography

Alesse, Craig. *Don't Take My Picture.* Amherst, N.Y.: Amherst Media, 1989.

Busselle, Michael. *The Complete 35mm Source Book.* New York: Watson-Guptill, 1988.

Editors of Eastman Kodak Company. *Kodak Guide to 35mm Photography.* Kodak Publications, 1989.

————. *Kodak Pocket Guide to Travel Photography.* New York: Simon and Schuster, 1985.

————. *The New Joy of Photography.* Reading, Mass.: Addison-Wesley Publishing Company, 1985.

Eastman Kodak Company. *How to Take Good Pictures.* New York: Ballantine Books, 1990.

Grimes, Caroline. *Using Existing Light.* Stamford, Conn.: Longmeadow Press, 1990.

Hajdu, David. *How to Shoot Your Kids on Home Video.* New York: Newmarket Press, 1988.

Hedgecoe, John. *Complete Photography Course.* New York: Simon and Schuster, 1979.

Hedgecoe, John, and Ron Van Der Meer. *The Working Camera.* New York: Harmony Books, 1986.

Herko, Robert. *Composing Photographs.* Stamford, Conn.: Longmeadow Press, 1990.

Kodak Limited. *How to Catch the Action.* Alexandria, Va.: Time-Life Books, 1983.

Stone, Erica. *Photographing Children.* Los Angeles: HP Books, 1986.

Index

action photographs, 110–115
aperture
 in choosing lens, 12
 and depth of field, 4, 6, 48, 114
 fixed, in compact cameras, 16
 function of, 3, 6
 how to choose, 4, 9
 size (f-stops) of, 4, 6
 small, 15
aperture priority, 15
"archival" materials, 29
ASA. *See* ISO (film speed)
autofocus cameras, 15–17
 for candid shots, 91
 and lighting, 34–35
 manual cameras vs., 9, 13–17 *passim,* 50, 83, 108, 112, 120
 predictive focus, 77
 and recomposing, 17, 35, 63, 108

baby pictures, 68–81. *See also* children
 lighting for, 68, 69, 72, 75, 79
background. *See also* depth of field
 blurring of (intentional), 4, 64, 134
 in composing shot, 48, 64, 119
 depth of field and, 11, 48, 101
 distance and, 48, 49, 57, 104
 lens size and, 19
 in party or group shots, 84, 91
 planning ahead for, 64, 84, 119, 141
 in portrait photography, 119
 in travel shots, 101, 104
 in video shots, 141, 143
backlighting, 16, 31, 36, 85, 142. *See also* light
batteries, 17, 89, 120, 130. *See also* flash
birthday parties. *See* party shots
black-and-white film, 75, 101, 126

vs. color, 21, 37, 93, 98, 115, 129
 lighting for, 36, 37, 98
blurring, 6, 7, 8, 112, 113
 background, 4, 64, 134
 panning and, 143
bouncing light, 41, 42. *See also* light
bracketing, 9
buying equipment. *See* how to choose

camera(s)
 autofocus vs. manual. *See* autofocus cameras
 for candid shots, 91, 95
 children's use of, 52, 137
 compact. *See* compact cameras
 disposable, 18, 108
 how to choose, 3–13, 15–19
 loading, 26–27
 "panoramic," 18, 19
 point-and-shoot, 16–17
 Polaroid, 18, 85
 range-finder, 16–17
 simple definition of, 3
 single-lens reflex. *See* SLR (single-lens reflex camera)
 for traveling, 101
 video, 140–145
camera shake, 98, 114, 120
candid shots, 128–139
 best camera for, 91, 95
children, 44–55
 age groups, 48–55
 babies, 68–81
 background for, 48. *See also* background
 dressing for the occasion, 46–48, 53, 64, 120, 122
 as element in composition, 55, 61–63
 eye level of, 57, 81, 89, 112
 eye level of, and red-eye, 39, 97
 portraits of, 116–127
 preschool, 50, 106
 school-age, 51, 52–53
 teenage, 54–55
 toddlers, 48–50, 124
 using camera, 52, 137

Christmas, 95–97, 124, 126–127. *See also* party shots
close-ups, 48, 49
 video, 143. *See also* distance
clothes (in children's portraits), 46–47, 53, 64, 120, 122
color, 32
 of clothes, 64, 122
color balance, 24, 98, 118
 correction of, in developing, 126
color film
 vs. black-and-white, 21, 37, 93, 98, 115, 129
 indoor light for, 24, 32, 36, 37
 prints vs. slides, 22–23, 24. *See also* slides (transparencies)
compact cameras, 16–17, 57
 for candid shots, 91, 95, 97
 child's use of, 137
 and flash, 39, 41–42, 94, 97
 SLR vs., 16–17, 101
 and snow pictures, 108
 for traveling, 101
composition, 31, 56–67
 background and, 48, 64, 119. *See also* background
 balance in, 63
 color in, 64, 122
 elements of, 55, 59–65
 focal point in, 63
 horizon line in, 60–61, 142
 position of subject in, 59–60
 "recomposing" (with autofocus camera), 17, 35, 63, 108
 "rule of thirds" in, 63, 106
 shape of subject in, 61–63, 66
 vertical vs. horizontal format in, 57
 with video camera, 141–142

darkroom, 21
depth of field. *See also* focusing
 aperture and, 4, 6, 48, 114
 definition of, 4
 demonstration of, 2–3
 with flash, 41
 lens size and, 11–12, 120
 shutter speed and, 69–70
 in travel shots, 101, 104

developing film, 21, 126
 correcting exposure errors in, 22
disposable cameras, 18, 108
distance. See also composition
 and background, 48, 49, 57, 104
 and bouncing light, 42
 close-ups, 48, 49
 depth of field and, 6, 12
 and flash, 39, 94
 in party shots, 89, 94
 and "rule of thirds," 63
 and snow shots, 108
 in travel shots, 104
 video close-up, 143
DX coding, 24. See also ISO (film speed)

emulsion, 21, 24
enlargement, 22, 28
establishing shot (video), 143
exposure. See also ISO (film speed); light; shutter speed
 aperture and, 3–4, 6
 automatic setting of (in newer cameras), 9, 15
 compensation for errors in, 9, 22, 89
 definition of, 3
 film speed and, 9, 24
 shutter speed and, 3, 6
 in snow shots, 108
eye level, shots taken at, 57, 81, 89, 112
 avoiding, to eliminate red-eye, 39, 97

family pictures, 91–93. See also group pictures
field. See depth of field
"fill-flash." See flash
film
 age of, 26
 black-and-white. See black-and-white film
 brand equivalents (chart), 27
 care of, 26, 28, 101
 color. See color film
 developing, 21, 22, 126
 how to choose, 21–29

negative (or print), 9, 22, 24, 39
 size of (35mm), 11, 16, 21–26
 size of (110mm), 16, 21
 slide (transparencies), 9, 22–23, 24
 speed of. See ISO (film speed)
 stocking up on, 89, 101, 106, 120
 storage of, 26
 XP2, 21
 X ray and, 28
film speed. See ISO (film speed)
finder, split-image, 13. See also viewfinders
flash, 36–42. See also light
 in baby pictures, 69, 75, 79, 81
 bouncing, 41, 42
 built-in, 16, 17, 39, 41, 97
 at ceremonies or performances, 81, 98, 99
 distance and, 39, 94
 "fill-flash" option, 16, 39, 42, 108
 lens size and, 12
 manual system, 41
 overuse of, 39
 for party or group shots, 83, 85, 86, 91, 94, 95, 97
 prohibited, 81, 99, 106
 and red-eye, 16, 39, 42, 97
 with SLR, 41–42
 synchronization speed and, 41
 TTL metering, 41, 42
focal length, 9
 differing, test of lenses, 10–11
focal-length number, 12
focusing. See also autofocus cameras; depth of field; viewfinders
 for action shots, 112–115
 autofocus vs. manual camera and, 13
 and depth of field, 4, 6
 focal point, 63
 focus lock, 17, 63
 for portraits, 120
 predictive, 77
 prefocusing, 113–114
f-stops, 4, 6. See also aperture
Fuji, 18, 26

grain, 23, 24, 25, 28, 29
group pictures
 dressing for, 46–47
 family pictures, 91–93
 at parties or performances, 86, 94–95, 99
 on vacation, 104, 106

Hajdu, David, 145
Halloween. See party shots
Hanukkah, 95, 124. See also party shots
holidays, 89, 94–97, 145
 holiday greeting cards, 124–127
horizon line, 60–61, 142. See also composition
how to choose
 aperture, 4, 9
 camera, 3–13, 15–19
 film, 21–29
 film speed, 9, 24
 lens, 12–13, 19
 shutter speed, 6, 9, 98, 114, 132
 video camera, 141
How to Shoot Your Kids on Home Video (Hajdu), 145

Ilford, 21, 26
ISO (film speed), 23, 25, 29, 35, 36
 for action shots, 114–115
 for baby pictures, 69, 72, 75
 for candids, 130, 132
 chart showing, 27
 DX coding for, 24
 for holiday shots, 97
 how to choose, 9, 24
 manual setting of, 24
 for portraits, 120
 for travel shots, 101

Kodak, 18, 26

lenses, 9–13
 of compact cameras, 16, 94
 focal length of, 9, 10–11
 f-stops of, 4, 6. See also aperture
 how to choose, 12–13, 19
 for portraits, 120

telephoto, 18, 54, 98, 114, 120
test of, 10–11
wide-angle, 11, 13, 16, 18, 101
zoom, 12, 13, 16, 57, 60, 98
light, 3, 31–42. *See also* flash
for action shots, 114–115
for baby pictures, 68, 69, 72, 75, 79
backlighting, 16, 31, 36, 85, 142
for birthday cake shots, 86
for black-and-white film, 36, 37, 98
bouncing, 41, 42
and color, 24, 32, 36, 37
direction of, 32
indoor, 24, 32, 36, 37, 68, 69–70, 72
intensity (contrast) of, 32
natural, 32–36, 69–70, 72, 97, 108, 118
for portraits, 32, 118, 119
reflected, 36, 108, 119
snow and sand and, 108, 132
time of day and, 34–36, 108
tungsten, 24, 98, 118
light meter
built-in, 9
and light on sand or snow, 108
TTL (through-the-lens), 41, 42
long shot (video), 143

manual camera vs. autofocus. *See* autofocus cameras
"manual overrides," 15
medium shot (video), 143
microprisms, 13. *See also* viewfinders
mirror-and-prism device, 15, 17. *See also* viewfinders

narration (video), 144–145
negative (print) film. *See also* prints
color balance in, 24
compact cameras and, 39
and exposure errors, 9, 22, 89
negatives, care of, 28

180-degree rule (video), 144–145

pan (video), 143
"panoramic" cameras, 18, 19
parallax problem, 17. *See also* viewfinders
party shots, 94–97
birthday, 48, 82–89, 143, 145
Halloween, 89, 94, 145
performances and transitions, 98–99. *See also* party shots
photograph albums, 29
planning in advance. *See also* composition
action shots, 111–112, 113–114
baby pictures, 72
and background, 64, 84, 119, 141
candids, 130, 132
party shots, 83, 85–87, 89
portraits, 117–120
travel shots, 101, 106
video shots, 142, 143
point-and-shoot cameras, 16–17
Polaroid cameras, 18, 85
portrait photography, 116–127. *See also* children
backgrounds for, 119
blurring in, 4
developing, 126
dressing children for, 46–48, 53, 64, 120, 122
lenses for, 11, 12
lighting for, 32, 118, 119
preparation for, 117–120
props in, 47–48, 54, 55, 72, 124
position of subject, 59–60. *See also* composition
postcards
commercial, of vacation spots, 102, 106
custom-made, from one's own prints, 125, 126
predictive focus, 77. *See also* focusing
prefocusing, 113–114. *See also* focusing

prints
advantage of, 22, 39, 89, 120
care of, 28–29
discarding, 28, 50
enlarging, 22, 28
negative film for, 9, 22, 24, 39
"program mode," 15. *See also* exposure
props, 47–48, 54, 55, 72, 124. *See also* portrait photography
PVC (polyvinylchloride), print damage by, 29

range-finder cameras, 16–17
"recomposing." *See* composition
Red Balloon, The (film), 64
red-eye. *See* flash
religious ceremonies, 81, 95, 99. *See also* party shots
rule, 180-degree (video), 144–145
"rule of thirds," 63, 106. *See also* composition

Scotch brand film, 26
self-timer, 120, 124
"shapes," subjects as, 61–63, 66. *See also* composition
shutter, definition of, 6
shutter speed, 3
in action shots, 114
and blurring, 6, 7, 8
camera shake and, 98, 114, 120
and depth of field, 69–70
how to choose, 6, 9, 98, 114, 132
test of, 5
shutter speed priority, 15
slides (transparencies)
"bracketing" for, 9
care of, 28
color balance in, 24
prints vs., 22–23, 39, 89
SLR (single-lens reflex) camera, 4, 13, 15, 19
autofocus, 15, 112
compact camera vs., 16–17, 101
disposable camera vs., 18, 108

SLR camera (*cont.*)
 and film speed, 72
 flash with, 41–42
 for portraits, 120
 viewfinder of, 15, 16, 17, 120
snow, 108, 132. *See also* light
speed. *See* ISO (film speed);
 shutter speed
speed, synchronization, 41. *See
 also* flash
split-image finders, 13. *See also*
 viewfinders
"stops." *See* f-stops
synchronization speed, 41. *See
 also* flash

telephoto lens, 18, 54, 98, 114,
 120. *See also* lenses
Thanksgiving, 94–95. *See also*
 party shots
transitions, performances and,
 98–99. *See also* party shots
transparencies. *See* slides
travel pictures, 100–109
tripod, 98, 114, 120
TTL (through-the-lens) metering,
 41, 42. *See also* light meter
tungsten light, 24, 98, 118

vacation pictures, 100–109, 145
vertical vs. horizontal format, 57.
 See also composition
video cameras, 140–145
 terms defined, 143–144
viewfinders. *See also* focusing
 compact-camera, 16, 17
 mirror-and-prism, 15, 17
 and parallax problem, 17
 and "rule of thirds," 63
 SLR (single-lens reflex), 15, 16,
 17, 120
 split-image, 13

wide-angle lenses, 11, 13, 16,
 18, 101. *See also* lenses

XP2 film, 21
X ray, effect on film of, 28

zoom lens, 12, 13, 16, 57, 60,
 98. *See also* lenses
zoom shot (video), 143–144

Photograph Acknowledgments

Pio Altarelli: p. 114
Christina H. Eckerson: p. 70
Patti Grimes: pp. 86, 89
Tony Jones: pp. 4, 5
Kathy Lichter: p. 126
Tara Phelps: p. 14
C. Reid-Eaton: pp. 95, 113
Uli Rose: pp. 53, 79, 80, 87, 105, 123
Mark D. Speed: p. 103
Marty Umans: p. 71, top; p. 125
Oliver Williams: p. 58
Peter Zander: p. 33; p. 71, bottom; pp. 76, 77, 109

Designed by
Cathleen Damplo and Douglass Scott
at WGBH Design

Typeset in Stone Sans